BEVERLY McIVER: FULL CIRCLE

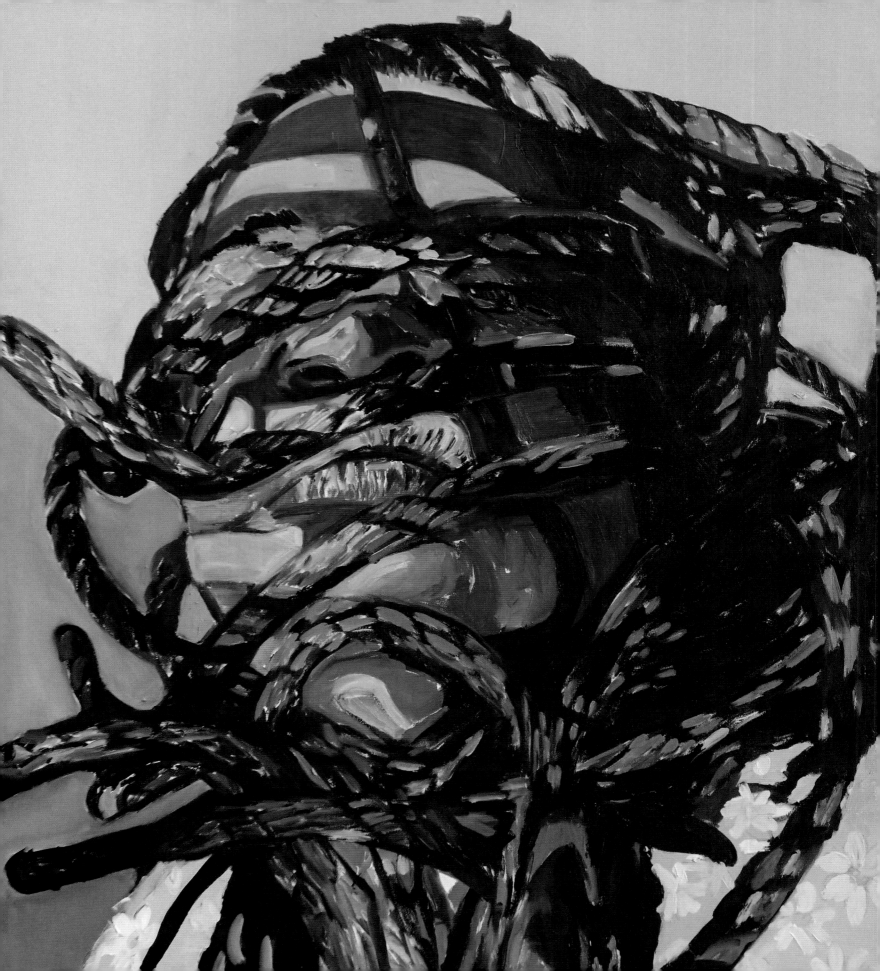

Edited by Kim Boganey

with essays by Richard J. Powell and Michelle Faith Wallace

BEVERLY McIVER: FULL CIRCLE

Scottsdale Museum of Contemporary Art

University of California Press

Beverly McIver: Full Circle is published on the occasion of the exhibition of the same name, curated by Kim Boganey and organized and presented by the Scottsdale Museum of Contemporary Art.

Exhibition dates:

Scottsdale Museum of Contemporary Art
February 12–September 4, 2022

Southeastern Center for Contemporary Art,
Winston-Salem, NC
December 8, 2022–March 26, 2023

The Gibbes Museum, Charleston, SC
April 28–August 4, 2023

Generous sponsorship for the catalogue and exhibition has been provided by World Class sponsor Wells Fargo Wealth & Investment Management.

Additional support has been provided by The Andy Warhol Foundation for Visual Arts.

The Andy Warhol Foundation for the Visual Arts

Published in association with University of California Press, Oakland.

Archna Patel, senior editor
Angela Chen, production coordinator

University of California Press, one of the most distinguished university presses in the United States, enriches lives around the world by advancing scholarship in the humanities, social sciences, and natural sciences. Its activities are supported by the UC Press Foundation and by philanthropic contributions from individuals and institutions. For more information, visit www.ucpress.edu.

Edited by Antoinette Parker
Copyedited by Tom Fredrickson
Designed and produced by Joan Sommers and Amanda Freymann, Glue + Paper Workshop
Color separations by Professional Graphics
Printed in China through Asia Pacific Offset

Library of Congress Cataloging-in-Publication Data

Names: Boganey, Kim, editor. | Wallace, Michele, contributor. | Powell, Richard J., 1953- contributor. | Scottsdale Museum of Contemporary Art, host institution.
Title: Beverly McIver : full circle / edited by Kim Boganey ; with contributions by Michele Faith Wallace, Richard J. Powell.
Description: Oakland, California : University of California Press, [2022] | Includes index.
Identifiers: LCCN 2021027262 | ISBN 9780520385191 (cloth)
Subjects: LCSH: McIver, Beverly—Exhibitions. | African American painting—21st century—Exhibitions.
Classification: LCC ND1329.M345 A4 2022 | DDC 759.13—dc23
LC record available at https://lccn.loc.gov/2021027262

All artworks are by Beverly McIver unless otherwise indicated.

Front cover: *Clown Portrait*, 2018 (pl. 50).
Back cover: *Life is Sweet*, 1998 (pl. 8).
Page 6: Detail of *Pre-Breast Surgery #2*, 2013 (pl. 44).
Page 10: Detail of *Loving Grace*, 2016 (pl. 49).
Page 24: Detail of *Clown Portrait*, 2018 (pl. 50).
Page 34: Detail of *Finding Peace #1*, 2009 (pl. 37).
Page 122: Detail of *A Woman's Work*, 2002 (pl. 16).

Photography credits

All images are courtesy of the artists unless otherwise indicated.

Ben Alper: pp. 6, 34; pls. 2, 4, 5, 10, 19, 21, 26, 32, 37, 42, 44, 54, 57, 61, 62, 63, 64, 79
Arizona State University Art Museum, Tempe: pl. 13
© 2021 Artists Rights Society (ARS), New York / ADAGP, Paris: p. 29, fig. 2
Courtesy of Kim Boganey: p. 22, fig. 3
Courtesy of Laura Lee Brown and Steve Wilson, 21c Museum Hotels: pls. 28, 51, 59
Ernie Button: pls. 20, 70, 71
© 2021 Covarrubias Estate / Yale Collection of American Literature, Beinecke Rare Book and Manuscript Library, Yale University: p. 30, fig. 3
Giano Currie: pls. 12, 30, 34, 35, 46
© 2021 Detroit Institute of Arts / Bridgeman Images: p. 37, fig. 2
Mitro Hood / courtesy of the Baltimore Museum of Art: pl. 16; p. 122
Beverly McIver: pp. 127–29
The Mint Museum, Charlotte, NC: p. 17
© 2021 Museum of Fine Arts, Boston: p. 27, fig. 1
National Portrait Gallery, Smithsonian Institution, Washington, DC: pl. 41
North Carolina Art Museum, Raleigh: pl. 25
James Prinz Photography, Chicago: pl. 27
© 2021 Faith Ringgold / Artists Rights Society (ARS), New York / Courtesy ACA Galleries, New York: pl. 65
Rockford Art Museum, IL: pl. 76
Rich Sanders / © The Estate of Francis Bacon. All rights reserved. / DACS, London / ARS, NY 2021: p. 31, fig. 4
Shark Senesac Photography: pl. 18
Olympia Shannon: front cover; p. 24; pl. 50
Claire A. Warden: pl. 15
Claire A. Warden / courtesy of the Scottsdale Museum of Contemporary Art: pl. 8; back cover
Weatherspoon Art Museum, Greensboro, NC: pl. 14

CONTENTS

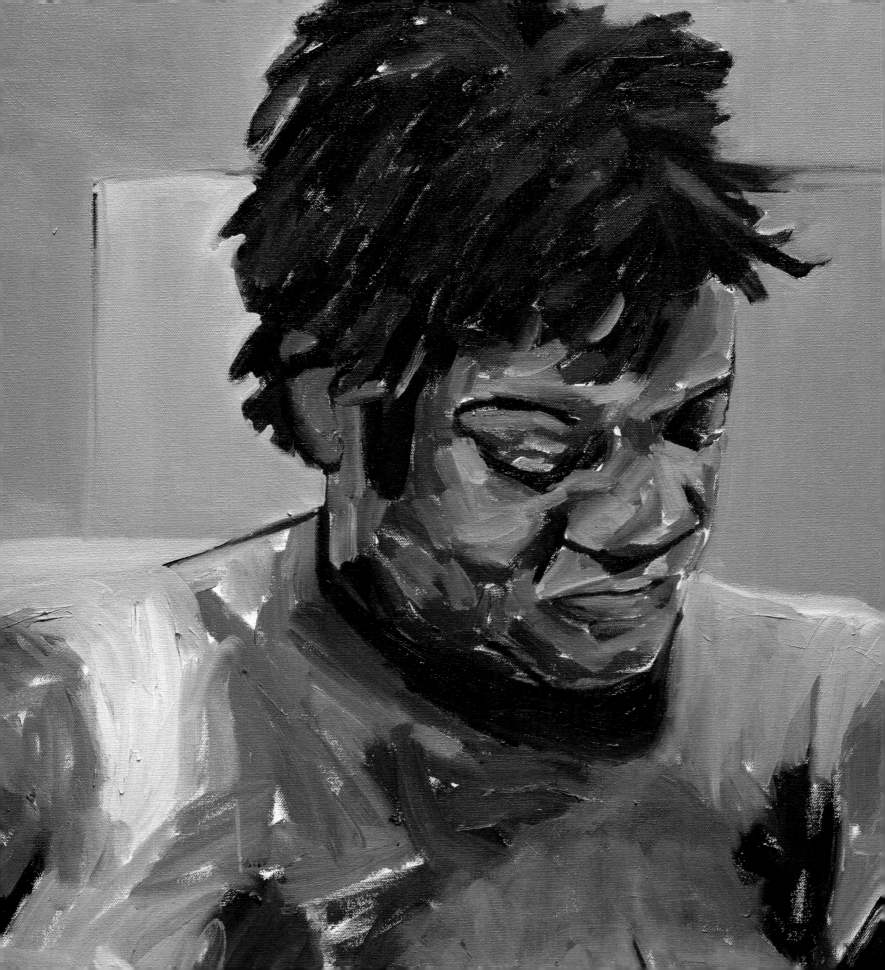

DIRECTOR'S FOREWORD

The Scottsdale Museum of Contemporary Art is honored to present *Beverly McIver: Full Circle*, a celebration of her significant artistic career spanning more than twenty-five years. The unprecedented exhibition of works by this critically acclaimed artist is accompanied by this monograph: the most comprehensive picture of her life and work to date. Through gorgeously textured paintings, mostly portraits, McIver faces head-on such complex topics as race and identity. She challenges the viewer to see all the colors that make up our complicated selves and ultimately expresses the commonalities and concerns we all share. We are deeply grateful she trusted us to handle such an ambitious project.

Part of coming full circle is returning to Arizona, a state McIver called home for twelve years. During that time many lasting friendships were formed, one of them with Kim Boganey, curator of the exhibition. I am immensely grateful to Kim for her bold vision of a large-scale exhibition and her exceptional skill in bringing it to fruition. Her interview with the artist allows McIver's voice to illuminate many of the experiences behind the paintings that we would not otherwise understand and that contribute greatly to her story and her relevance.

Our deepest thanks go to the other contributors to the catalogue. Richard J. Powell traces multiple lineages for McIver's work, underscoring concepts rooted in portraiture, abstraction, and post-Black identity that are intertwined with investigations of the materiality of paint itself. Michelle Faith Wallace, daughter of Faith Ringgold, explores the nuances of being a female African American artist through her mom's eyes and through Beverly's. Faith encouraged Beverly at a critical point, and the role of mentorship

surfaces as an important thread running through her work.

Even before the social uprisings of summer 2020, we decided, as an institution, to dedicate as much time and as many resources as possible to solo exhibitions with artists of color. Accompanied by catalogues, these exhibitions are an important contribution to the woefully inequitable field of art history. We are sincerely grateful to the Andy Warhol Foundation for the Visual Arts, which acknowledges and gives agency to our efforts, and to Billie Jo and Judd Herberger for believing in and supporting all the arms of Scottsdale Arts.

A special thank you goes to Southeastern Center for Contemporary Art in Winston-Salem, North Carolina, for recognizing the importance of such an endeavor and partnering with us early on, especially curator of contemporary art Wendy Earle and director William Carpenter. Gratitude also goes to the Gibbes Museum in Charleston, South Carolina, especially director of curatorial affairs Sara C. Arnold and director Angela Mack.

As with any project of this magnitude, it would not be possible without the tireless support of the incredible museum staff in tandem with the support staff at Scottsdale Arts. I would like to especially thank Gerd Wuestemann, president and CEO of Scottsdale Arts, for his leadership and backing of all our efforts in the realm of diversity and inclusion at the Scottsdale Museum of Contemporary Art.

Jennifer McCabe, PhD
Director and Chief Curator
Scottsdale Museum of Contemporary Art

ACKNOWLEDGMENTS

Who would have guessed that the serendipitous meeting of two young African American women in a hallway at Scottsdale Center for the Arts (now known as Scottsdale Center for the Performing Arts) would result in a close friendship that, at its core, includes a singular love of the visual arts, a deep commitment to our families, a desire to see other people of color succeed in the arts, and a passion for shopping when we were overdue for some stress relief? I have been honored to see how Beverly McIver's career has continued to evolve and ascend as a result of her power as a painter and her gift for visual storytelling—her story as well as those of her friends and family. I am grateful to present *Beverly McIver: Full Circle*, a survey exhibition that explores, for the first time, the arc of the artist's career and how others have shaped her work, as well as how she, in turn, has influenced others. Beverly McIver is a prolific painter. I hesitate to guess but estimate she has created many hundreds of paintings over the last thirty years. *Full Circle* brings together more than fifty key paintings, allowing viewers to see for the first time the evolution of her work, along with the story of her life.

I am grateful to Scottsdale Museum of Contemporary Art for its acceptance, without any hesitation, of my proposal for this exhibition back in 2019. The belief of the museum's director and chief curator, Jennifer McCabe, provided the fuel that catapulted this project forward. I also thank the SMoCA team for being an incredible group to work with on all aspects of this exhibition, including Valerie Ryan, assistant director; Carrie Tovar, registrar; Laura Best, exhibitions manager, and her amazing team of preparators; and Keshia Turley, curatorial assistant. SMoCA's curator of contemporary art, Lauren O'Connell, provided an invaluable connection to University of California Press, for which I am in her debt. I will always be grateful to our president and CEO, Gerd Wuestemann, in addition to the Scottsdale Arts Board of Trustees for their continual support of this exhibition.

I am thankful for the family of sponsors that provided support for the exhibition and catalogue. Many thanks to World Class sponsor Wells Fargo Wealth & Investment Management, as well as the City of Scottsdale, the Andy Warhol Foundation for the Visual Arts, and the National Endowment for the Arts for their generous support. Many partners stepped up and collaborated with us to ensure the broadest reach possible, including Arizona State University's Grady Gammage Memorial Auditorium and artist Eiko Otake, whose collaborative performances with Beverly have exposed new audiences to her breathtaking artistry. Additionally, programming collaborations allowed for educational opportunities that tied into Beverly's attention to subject matter regarding life, family, aging, caretaking, and personal struggles. We are thankful for the partnerships with such organizations as the Opportunity Tree, Scottsdale Unified School District, and Paradise Valley Unified School District.

There are many individual and institutional collectors of Beverly McIver's artwork. We are indebted to the private collectors who have lent their work to the exhibition: Lee and Elizabeth Buck, Ernie and Melissa Button, Nick Cave, Claudio Dicochea, Michael Dixon, Godfrey Herndon, Carrie Hott, Noel Kirnon and Michael Paley, Peter Lange, Craig Pearson, Matthew Polk and Amy Gould, Judi Roaman and Carla Chammas, Chris Santa Maria, Damian Stamer,

Billie Tsien and Tod Williams, Jane Shuping Tyndall, Douglas Walla, Lawrence Wheeler, Lamar Whidbee, and Paul and Christy Winterhoff.

We also thank our colleagues at the institutions that were willing to part with their artwork for the duration of the exhibition: Alice Gray Stites and Laura Lee Brown at 21c Museum; Elisa Hayes at the Arizona State University Art Museum; Dorian Bergen at ACA Galleries; Nicole Wise at the Baltimore Art Museum; Jonathan Stuhlman and Katherine Steiner at the Mint Museum; Dominique DelGiudice at the National Portrait Gallery, Smithsonian Institution; Maggie Gregory at the North Carolina Art Museum; Carrie Johnson at the Rockford Art Museum; and Emily Stamey at the Weatherspoon Art Gallery.

Beverly McIver is represented by several galleries nationwide, and we would be unable to track all the details pertinent to this exhibition without their generous assistance, including Constantin Grimaldis at C. Grimaldis Gallery, John Bloedorn and Keith Allen Wenger at Craven Allen Gallery, Betty Cuningham and Jessica Kitz with Betty Cuningham Gallery, and Bernice Steinbaum with Bernice Steinbaum Gallery.

We are excited that the exhibition will travel on to two additional venues after its presentation in Scottsdale. I am indebted to curators Wendy Earle at the Southeastern Center for Contemporary Art in Winston-Salem, North Carolina, and Sara Arnold at the Gibbes Museum of Charleston, South Carolina, for their commitment to this exhibition, even during times of uncertainty while experiencing the impact of the Covid-19 pandemic on their communities.

I must acknowledge the critical education that Beverly McIver received from key professors in her life. Elizabeth Lentz, Richard Mayhew, and Faith Ringgold nurtured Beverly so that she could master her skills as an artist, become savvy at the business of being an artist, and then ultimately impart this knowledge to the next generation of students. Beverly has indeed now mentored others, and some of their work is included in this exhibition as a testament to her influence. We are grateful to artists Melissa Button, Claudio Dicochea, Michael Dixon, Carrie Hott, Mary Porterfield, Chris Santa Maria, Damian Stamer, and Lamar Whidbee for lending their artwork. They are just a few of the many former students who gratefully acknowledge the nurturing that Beverly provided. I do hope they, in turn, will pay it forward.

I am so grateful for the written contributions of Richard Powell and Michele Wallace, both of whom provided distinctly different and thought-provoking perspectives on understanding Beverly's work within the canons of art and social history. I am thankful to the staff at University of California Press, under the guidance of acquisitions editor Archna Patel, for their immediate belief in this project. The team at Glue + Paper, including Amanda Freymann and Joan Sommers, provided expert creativity in producing the catalogue you have before you. Many thanks are extended to Tom Fredrickson, Antoinette Parker, Virginia McInnis, and Brian Passey for their editorial eyes. We appreciate photographer Ben Alper filling in the gaps by getting beautiful imagery of objects for which high-resolution images were not otherwise available.

Thank you to Scottsdale Public Art staff— Gina Amato, Gina Azima, Tanya Galin, Jennifer Gill, Susan Hardiman, Kayla Newnam, and Wendy Raisanen—who have been patient and understanding in allowing me to do double duty as their director while also working on this massive project.

To my family, friends, and colleagues, who have been understanding and cognizant of my time on this project, I am grateful for your passion, support, and keen editorial eyes, all of which have kept me buoyed when the immensity of the work appeared overwhelming. My mother, Dolores Curry, was a sounding board and passionate cheerleader, particularly when it was difficult for me to find my way through to clarity. And to my extraordinary husband, Stanley Boganey, thank you for all that you do for me every day.

Most importantly, thank you to Beverly McIver for being a gifted painter, a collaborator, a confidant, a free spirit, and the best friend outside of family one could ever hope for. For the last thirty years, your paintings have been an incredible gift to the world. I look forward to seeing what the next thirty years bring.

Kim Boganey
Curator

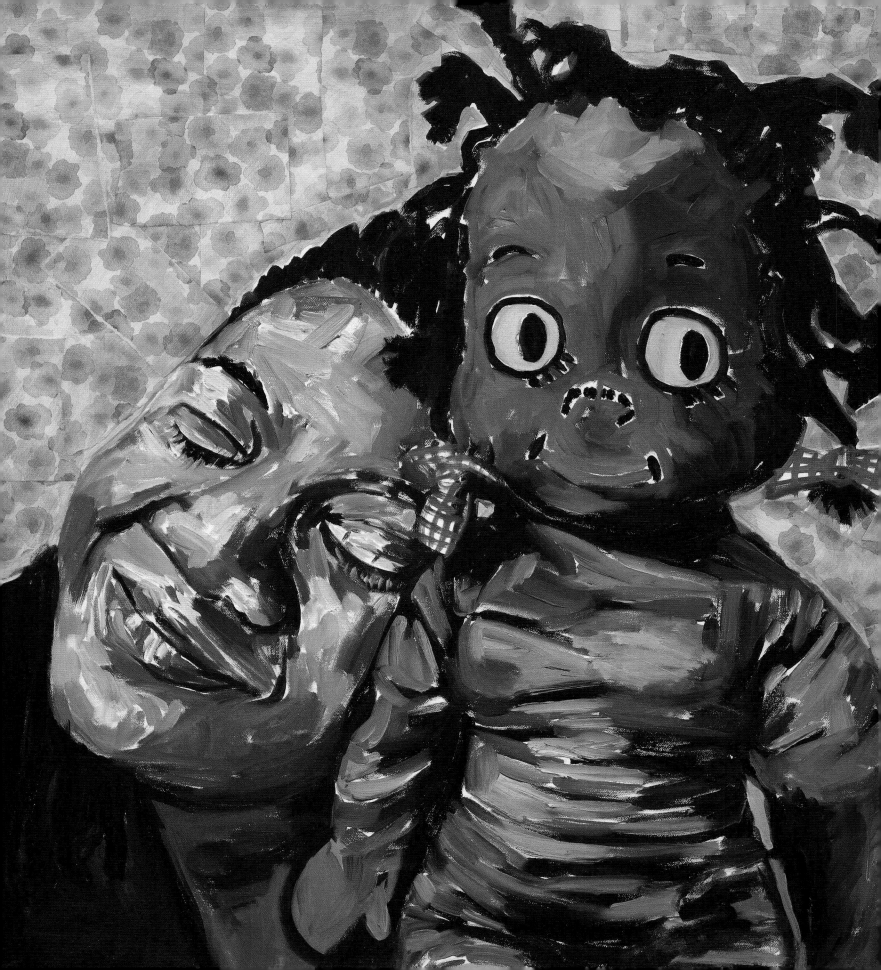

A Conversation with Beverly McIver

Kim Boganey

Kim Boganey I have read many of the articles written about you over the years. They talk more about your life and less about your art. Do you ever wish that these writers would write about something else?

Beverly McIver I don't know what that something else would be. I think people have accused my work of being too personal, and for some people that is a negative. To offer a context for that very personal work, writers must talk about who I am, how I was raised, and what I am today. I hope it comes full circle in that they say something about me being a humanitarian, with an understanding of how I was raised.

KB Your artwork *is* personal; it is your life. Other artists don't necessarily approach it from that perspective.

BM It is more difficult to talk and paint about one's personal life—in an authentic way—because you're constantly evaluating yourself and how you're living and how you're walking through the world.

KB How did you decide to study art, and why did you pick North Carolina Central University?

BM I grew up in Greensboro, North Carolina. I had always been bused to white schools, and then I was returned to the housing projects, which were all Black. It was important for me to choose a historically Black university because I had this uneven belief in white life and Black life, with Black life being negative. I wanted to go someplace where I could see positive perceptions of educated African Americans, who were not much different, except for skin color, from the middle-class white people I knew in high school.

KB What made you decide to pick art as a major?

BM I had several majors before art. In my second year I changed from being a psychology major, which is why it took me five years to graduate. I met this nice guy who was in the health industry. He thought I was so kind that I'd be great in health care. But then I took an art course as an elective, and that is when I met Elizabeth Lentz, who was a white art professor teaching at NCCU. I became an art major because she thought I was good at painting.

KB It's ironic that the inspiration for your becoming an art major was a white woman.

BM Keep in mind that, prior to this, the overall messages that I had been getting were that white was good and Black was bad. The fact that she was a white teacher at a Black institution confirmed in my head that I was going to get a great education because she looked just like everybody that taught me in high school. I ended up having classes with her every year, since the art department was small.

KB There were several other art professors who were Black at NCCU.

BM Chester Williams taught sculpture. He thought I should become a sculptor. I am really a princess, so the idea of having a hammer and being outside to do sculpture and get dirty was not my cup of tea. Elizabeth would invite me over to her house so that we could paint together.

This was an important way of her showing me that she believed in me and my talent. She was doing self-portraits and still lifes (pls. 61–62).

KB Do you see this as her influence on you?

BM Yes. For years after I graduated from NCCU, people would tell me that I needed to find my own voice, that my work looked too much like Elizabeth's. As an example, she taught me about color mixing, so our palettes were remarkably similar. She loved luscious paint; I did, too. It wasn't until I went to graduate school that I started talking about conceptual ideas and being more serious about my intent.

KB Fast forward to your time at Pennsylvania State University, where another artist-professor became a mentor: Richard Mayhew.

BM Penn State representatives visited NCCU looking for the two best art students to attend Penn State's graduate school on full scholarship. The head of the department at NCCU selected me and this other girl, who happened to be white. We flew to Penn State. That is where and when I first met Richard Mayhew. I knew I wanted to study with him when I saw his paintings. This was around 1987. I later found out he had only a couple more years at Penn State before retiring.

KB It must have had an enormous impact on you, seeing an African American professor and painter. What of his work did you see while you were at Penn State?

BM I remember seeing beautiful landscapes that supplied a real understanding of color and warmth, all the things that I was interested in as a painter. I took his course on artistic professional development and how to get gallery representation. I desperately wanted him to be on my thesis committee, but he couldn't because he was leaving. He would occasionally come to my studio and make a couple of comments.

KB This obviously had a significant impact on you, not only as a working artist but also in terms of how you are shaping the next generation of artists.

BM Richard took us all to Washington, DC, and New York to visit museums and galleries. He would take the entire class and say, "Let's go." It gave me a view into the art world and instilled in me my love for travel. Prior to that, I hadn't really traveled anywhere.

KB What about the larger environment at Penn State?

BM I was accepted to Penn State because they thought the work I was doing with still lifes was beautiful. The faculty would take the paintings from my studio and show them to their painting classes and tell them that this is how you should paint. At the beginning of my second year, however, I started painting portraits of Black people: family members and community members. The white faculty kept stressing to me that nobody would buy this artwork. Support for my work went awry. I remember sitting in my studio being so depressed. I was thinking that I would just return to painting still lifes, get my degree, and leave. One day Richard came into my studio and showed me a portrait he had just completed of a Black woman (pl. 64). He asked me if I liked it. I thought it was absolutely beautiful. He told me that I can make portraits, too. He left the pastel with me, and he went away. I decided I must get back to doing portraits.

KB It sounds like things got worse for you at Penn State.

BM Aside from the faculty comments, there weren't any real signs that this would derail my getting a degree. I had enough credits to graduate, and I had drafted my thesis paper. My thesis exhibition consisted of portraits of people I felt had influenced my life, for the good and for the bad. There were about twenty portraits, several of them with me in the center. You could tell if the person was a good or bad influence by how they were conveyed in the paintings. I had a portrait of Richard Mayhew, and he was up front and upright. But then I had a portrait of another professor, with his torso turned on the side. He was probably the meanest person I had met to date. The good news is he taught me what white males are willing to do if they feel threatened because of entitlement—that kind of entitlement where you are okay if you don't threaten them. The minute they are threatened, they want you to know they are willing to take you down even if it means taking themselves down.

For my oral exams, this professor told me not to worry about preparing intellectual answers to a set of questions that the university should have provided to me, but that I should just go in and talk about my work and influences and pull from my thesis paper. In short, my committee said I failed my orals and my thesis exhibition, so I should come back in a year and submit again. I said I didn't want to do that. I had other commitments already in play. I could not believe this was happening. Why didn't they tell me sooner? There was no indication I would get to this point and fail. I was completely devastated. It still makes me mad. I feel I got burned for being Black, poor,

Fig. 1

Self-Portrait, 1992. Oil on canvas with quilted fabric; 30 × 30 in.

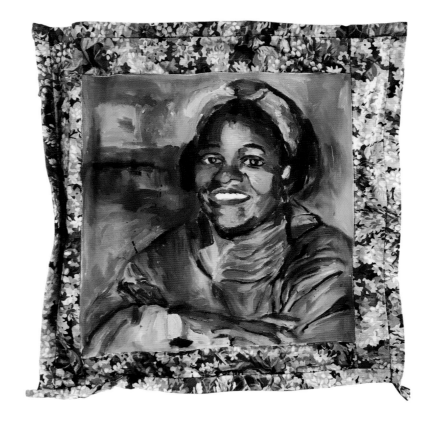

and a woman. It didn't help that all three of my committee members were white males.

KB This is where your third major mentor, artist Faith Ringgold, enters the picture. How did you meet her?

BM She visited Penn State that following fall. She was giving a lecture with the women's studies department, which I went to hear. After the lecture, I walked to the stage and told her what was happening to me. I asked her to come to my studio and help me. Mind you, this is at night; I'm sure she's tired, and here I am, nervous and begging, basically. When she told me how tired she was, I instantly started crying. Faith then told me to get a couple of paintings and bring them to her. I took off running and grabbed a couple of wet paintings, which I got all over my clothes. Whoever was sponsoring the event asked if she needed a cab to get back to the hotel for a 4 a.m. pickup. I volunteered to take care of Faith. She looked at my paintings, then we ended up at an all-night diner, where we talked until about 2 a.m. She thought I would make a great assistant and asked me to come be her assistant at the Atlantic Center for the Arts [in New Smyrna Beach, Florida], where she was in residence. Penn State had broken my spirit. I knew that if I told my committee, these three white males, about this opportunity with Faith, they would surely say no. They wanted me to fail. So I went over their heads to the dean, who not only said yes but also supplied the funds for me to go.

KB Wow.

BM Once they were told, the committee said I would not graduate in May if I left. I would essentially have to start over with another exhibition

and oral exam once again. I was okay with this because I wasn't painting, and I was wasting my life. I needed to be around somebody who looked like me, who could nurture me, tell me I was a good painter, and bring that part of me back to life. I left, and I went with Faith.

KB Faith had a noteworthy influence on your second graduate thesis exhibition. Your work (fig. 1) was similar to hers, in that she uses quilts as canvases for portraits of herself, family, and friends.

BM Yes. I had a sewing machine while I was with Faith. The experience was delightful. I went back to Penn State and presented my thesis exhibition again. The committee informed me they would pass me, but they thought I was ill prepared, should never apply for a teaching job, and certainly not ask for a letter of recommendation. By this time, I was teaching at NCCU and was making art. I didn't say anything, and I didn't go back

that afternoon for commencement. They mailed my degree.

KB You didn't talk to Penn State for many, many years. And yet they came back into your life later.

BM In 2003 they awarded me the art department's Distinguished Alumni Award for my contribution to the arts and because I was doing so well. When they called me about it, I laughed. I called Faith, who said to accept the award and tell my story. My mother told me to simply accept the award, sit down, and leave the past in the past. I was so nervous. When they called me to the stage, I kept telling myself, "Just say thank you and sit down." I started by thanking Penn State for this award, and then I stopped. I started again and said, "When I was here, I experienced both racism and sexism. It was a really, really challenging time that has scarred me. I accept this award as an apology and hope that it never happens to any other student." The audience was

quiet. There was a professor in the audience who was weeping. She knew what had happened to me and knew there was no one at the school who would help me. In 2010 I was awarded the Alumni Fellow Award for all of Pennsylvania State University. They came back a third time to offer me a position, which I declined.

KB This is a full-circle moment. Your first graduate exhibition consisted of portraiture, which is a happy place for you—creating portraits of friends, family, and people you admire. In 2020, with the stresses of Covid-19, civil unrest, and social upheaval, you are back in that happy place, painting portraits.

BM Absolutely. I enjoy painting people. This guy once said to me, "I see God in you." I'll never forget that. I think the people I choose to paint today are people that I see a part of myself in, or they have qualities that I would like to have or build upon. That is what I try to capture in my paintings—the essence of those human beings. People in this world may try to bring you down, much like what happened to me at Penn State, but you must persist and focus on that which brings you back up.

KB What was the inspiration for painting portraits of your older sister Renee, who was your first dedicated subject matter?

BM I started painting portraits of Renee because I was looking for a physical being that represented my own marginalization in the world. I was at Penn State at the time. I was looking for someone who struggled with difficulties over which they had no control. Renee is intellectually disabled and has epilepsy, which she cannot control.

KB Were you taking photographs of her and painting portraits from the photographs?

BM No, not in the same way that I do today. I took very few photographs of Renee since film was expensive and I could not afford it at the time. The first paintings of Renee are those where I scratched out her smiling face. At the time I didn't realize I felt Renee was basically making me invisible because she was so big and always at the center of attention. As the baby in the family, I disappeared.

KB At the time you must not have been expecting to display these portraits publicly because they were so deeply personal.

BM I try not to think about the public or how people will respond. I keep this at an arm's distance. You will always have naysayers, people who are so judgmental. I now have the vocabulary to talk about it, but at that time all I knew was that I had ruined a couple of expensive paintbrushes by scratching Renee's face out. It was Elizabeth Lentz who told me to keep at it.

KB What did your family think of these portraits of Renee?

BM My family first saw the portraits at an exhibition organized by Elizabeth. I was nervous. My oldest sister, Roni, felt I was putting our family's business out in the street. My mother understood because she knew it was no secret that Renee was a handful. Renee came up to me at the opening and asked why I scratched out her face in the paintings. I remember standing there feeling completely helpless. We were interrupted, however, by someone who said to Renee that her portraits were beautiful and asked if she liked them. She said yes. I realized I didn't have

to answer anymore because Renee realized she was the center of attention. She was fine, and she never asked me again.

KB You started painting yourself as a clown about 1995 or 1996, around the time you joined the faculty at Arizona State University in Tempe.

BM Actually, my first painting of me as a clown occurred when I was an undergraduate at NCCU because I was a clown in high school. I remember me and my friend Jewel dressed in clown makeup. The painting represented being white, being liberated from the projects and poverty, and a departure from people like me. I showed the painting to Elizabeth, my teacher. She laughed aloud and told me to look up James Ensor, an artist known for his clown portraits. I remember being shocked that she laughed. I didn't revisit painting self-portraits in clown makeup until after I graduated from Penn State (fig. 2).

KB What brought you back to painting self-portraits as a clown?

BM Around 1993, I attended a performance at Duke University's American Dance Festival. There was this performer dressed in blackface. I remember sitting there thinking, "Oh my God, I can be a Black clown; I don't have to be white." I had to be white in high school because that was the rule for the clown club. The next day I went to a Halloween shop and bought an Afro wig and black grease paint, and I became a Black clown.

KB Around this time, you were having gallery exhibitions of your portraiture, but then you also

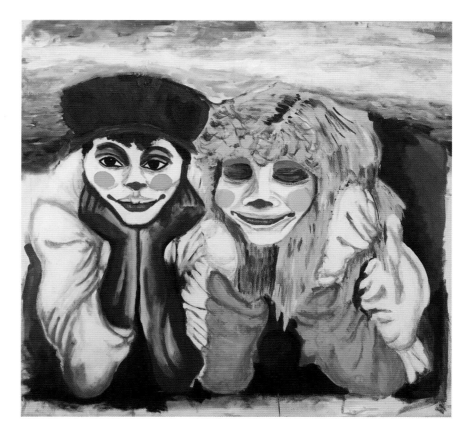


Fig. 2

Beverly and Jewel, c. 1986. Oil on canvas; 24 × 30 in.


debuted the self-portraits in black clown makeup. Do you recall your family's reaction?

BM I have always kept a journal. And one of the things that was on view with the exhibition was a journal, which helped provide context for the portraits. For example, the journal talked about being a clown and going from whiteface to black-face. In the beginning I didn't think my family had a problem with the portraits. They knew I had tried out for Ringling Bros. and Barnum & Bailey Circus. My mother was horrified but happy that I had found something that I loved to do. Mom said that being a clown was one of the first things I said I wanted to be.

KB I recall the story about how, as an undergraduate, you stopped doing side work as a clown because of the three-year-old kid who saw your Black skin under the white clown makeup and was horrified that you were Black underneath the makeup.

BM I told myself I would never do that again.

KB I can see how your paintings probably took a lot of people by surprise because they were unlike anything anyone had ever seen, particularly in North Carolina. It is one thing to see portraits; it is another thing to see self-portraits of a clown in black makeup. The journals must have been helpful for viewers unfamiliar with your artwork. Why did you start journaling?

BM I was a loner when I was a kid. I was incredibly shy. I still am; people don't believe that, but it is true. I wanted an outlet for things I couldn't talk to people about, like feeling trapped in the projects. And the only freedom I had was being a clown and hiding behind the clown makeup because then everybody loved me. You can't

say that aloud to anybody. So journaling was an outlet for me to really be in touch with my feelings and give voice to all the things going on in my head. I have a bunch of journals from grade school, high school, and my undergraduate years, but I don't write very much anymore. I haven't done much journaling in the last two or three years.

KB Why not?

BM I think I feel sad and heartbroken in a way I don't want to remember or bring to the forefront. That is what journaling does. My paintings do the same thing, but if you're a viewer of the paintings, you can just look at the colors and say, "Oh, that's a beautiful painting," and you can forget all the other heavy stuff that's around it. With journaling, you can't do that. I think there are some real ugly truths in there that I'm not interested in addressing—at least these days.

KB It is quite a shock to hear you say you stopped.

BM I have journals that are a third full. I think it has to do with a sadness that I have for the world and for humanity, which is a bit too overwhelming for me to write about. I think this happens to a lot of artists. You push your way through. As you get older, you get to a point where you give yourself enough encouragement to keep going.

A reporter recently said to me that perhaps I have been so busy being an artist that I forgot to be me. Or to live. I didn't know what to say to that. But that speaks to teetering on the edge, and I'm not interested in going there because I think I'll fall. That's in part why I don't write anymore. It is just too painful an experience to face.

KB I believe it was with the painting *Dancing for My Man* (2003; pl. 18) that you finally took off

the clown makeup and began portraying yourself unadorned. What caused you to do that?

BM I remember it was important for me to not wear makeup. I knew it was time, and the paintings that came afterward allowed me to be open with myself—and with others.

KB It wasn't until 2017, when you spent a year at the American Academy in Rome, that you put the makeup back on. What happened?

BM I think it is the same thing that brought it on when I came to Arizona. I was in a place that made me feel very, very Black. While living in Rome, I was stripped of my comfort zone, since I didn't speak the language, felt quite isolated, and was living in this big mansion with other fellows who were very, very smart. I didn't feel like I didn't belong there, because I knew I could paint as well as they could speak or write. But it did make me feel like, as a Black person, you must be twice as good. I felt like, in addition to being a great painter, that I also needed to read the *New York Times* every morning so I could be a part of their world.

KB So you put the makeup back on because you were exhausted?

BM That was part of it. It was triggered by a Halloween party. Everybody asked me what I was going to dress up as. Many of the fellows were art historians, so some of their costumes were based in mythology. They were thinking of these very sexual women who were also powerful vixens. I thought I could be a clown. I hadn't put on makeup in years.

KB Did it feel good putting your makeup back on?

BM It felt great. I was cute because my hair was in exceptionally long dreadlocks. But people were staring at me at the party, thinking that I was in blackface. They did not think it was cute or funny. One of the fellows' husbands asked me why I could dress up in blackface and he could not. What gave me permission to do that? I said that, because I'm Black, this is authentic to my life. It is a part of who I am and the beginning of how I came into loving the performing arts in high school as a clown.

KB How did you feel about doing a portrait of Larry Wheeler, a white male, in blackface (2018, pl. 54)?

BM Larry had commissioned me to do his portrait, since he was retiring as the longtime director of the North Carolina Museum of Art. He wanted to be portrayed in blackface. Initially I told Larry that wasn't the best way to address his authentic self. Everyone was going to hate him for doing this, putting him out there on the ledge. I didn't know if I wanted to be out there on the ledge with him. Larry felt that since he was retiring, he didn't care anymore what people thought. He told me about this isolation of growing up in the South, being gay, and feeling like he was Aretha Franklin in this white male body. I realized I understood what he was talking about, so I wanted to honor that.

When I paint portraits of people, I'm interested in two things: I'm interested in finding myself within them, and I'm interested in painting their authentic selves. Larry met both those criteria, so I painted the portrait. I think the only way he could signify being a Black person was by putting on blackface. I didn't choose this lightly. I

can't think of how else I could have painted him to have the same point come across.

KB When I look at Larry's portrait, I feel his portrayal is coming from a place of privilege, knowing how charged that imagery is for African Americans, particularly in the twenty-first century. The rest of us would be very respectful of other people's history and not appropriate, because we would not want to offend. It is still a very charged way to portray Larry's authentic self.

BM I believe that I have sometimes upset people when I have shown my authentic self. I must have courage when portraying my authentic self, whether people can appreciate it or not. When people see my *Depression* paintings (2010; pl. 38), it is so uncomfortable for them because they've been there themselves. But nobody really wants to acknowledge those painful aspects of life because it may imply something is wrong with you. Don't forget the early paintings of Renee, where I scratched her face out. I've been doing provocative things my entire artistic career. People project their own experiences onto the paintings. That is what art should do.

KB I have always been fascinated by your lovely backgrounds. That's another thing that is distinctly yours in terms of that depth of color, the lushness, and how you apply paint.

BM I think it came from looking at the paintings of Mark Rothko, Nathan Olivera, and Richard Diebenkorn. Their works would have these rich fields of color. In my head, I always put a figure in the middle of these color fields. I understand what Rothko wanted to achieve by making very atmospheric paintings with infinite space

that you visually walk through and disappear. I decided I wanted to have that kind of background in addition to having a visual resting place, because sometimes what I place in the foreground can be too heavy for most people. I thought if I make a beautiful background, then people who are afraid of topics like racism won't see it. They'll see a lush painting with some figure standing in it, and they won't be alarmed.

Those who are willing to go there will see there is a contradiction between the foreground figure and the background, which is how my life is. It reflects so much of how I have walked through this world. When I moved to Arizona [in 1996], I was depressed for months, in part because I felt I was one of the few Black people out there. All that is familiar to your environment and your surroundings is snatched away from you. Initially, I couldn't find soul food, a Black radio station, a Black church, or a beauty salon. The things that I took for granted in North Carolina appeared to be gone. So I was simply trying to rise out of it and not fall apart.

KB I met you for the first time at your 1998 solo exhibition *All of Me* at Scottsdale Center for the Arts.[1] As the museum's registrar, I was there to check on the artwork. For whatever reason, I honestly had no idea about you up until the moment I walked into the exhibition space and saw you—another Black woman in Scottsdale who was in the arts. It was remarkable at that time.

You always had a command of paint, but you also had the ability to share your personal history. I truthfully believe that's where your career really started to take off because your subject matter was so different, interesting, and provocative.

BM I recall the exhibition had some tough paintings.

KB The center was taking a huge risk to show these amazing paintings of you with this audience having zero understanding of who you were.

BM I remember speaking at the opening. The theater was packed, with more Black people than I had ever seen in my whole stay in the state of Arizona. A Black guy asked me about a painting in the exhibition titled *Stand*. He asked why I wrote that word in the painting and what it meant. I suspected he was thinking about this song by BeBe and CeCe Winans called "You Just Stand." The painting is symbolic of my mother, who was a big churchgoer and who would say, "When you are going through a rough time, just stand still, and it is going to be alright." In that painting I am dressed in my mother's church gloves, which she gave to me when I wanted to be a clown.

KB *All of Me* was your introduction to people outside North Carolina, their chance to know who you are and your power as a painter. After that you began several series—*Loving in Black and White* (1998–99; pls. 9–10) and *Mammy, How I Love You* (1999; pl. 12)—where you used costumes to place yourself at the center of narratives speaking to personal experiences about love and your mother's life as a domestic worker.

BM While at Arizona State University, I had access to the theater department. I couldn't wear their costumes because I was too big, but I got permission to go backstage and take pictures as well as to use the props. I reenacted scenarios of things my mother would have done as a domestic worker, like ironing and washing dishes. There were also all these dolls backstage as well, and,

of course, they were all white. I incorporated the dolls into my portraits. I decided to make the narrative bigger, so that it was not simply personal but that it is also universal, in that others felt the same way or grew up like I did. Many African American children in the South grew up with mothers who were caretakers for white families and their children, so this was an opportunity to act out these narratives.

Also keep in mind that I was in my thirties when I arrived in Arizona. I was looking for a partner, but it never occurred to me that I would likely need to date someone white. I thought, There has to be some brothers out here, but I don't see where they are. I can clearly remember thinking that I must learn how to look at white men, which speaks volumes about how we're trained about what beauty is, what sexy is, and what is alluring. I remember staring at white men. Most of my colleagues were white males, and I'm looking at them and thinking, Is he cute? Can I see myself sleeping with him? I did that for a long time.

KB The connotations with *Loving in Black and White* and the sexualization of the mammy figure are loaded. I know at one level you are telling the story about what it is to find love in Arizona or wanting to shed light on your mother's history. Now, however, the figures have become powerful symbols of identity and empowerment. Later, instead of sharing your mother's history through narratives, you began painting portraits of her. Did you ever talk with her about wanting to become a painter?

BM I don't know if I went to her and said I wanted to be a painter. I know my mother was glad my sister Roni and I were the first generation to go

to college. My mother was enormously proud of me, but she would have preferred that I take a traditional route. She had me question everything, though.

KB I haven't seen many portraits of your mother from your time in college.

BM Most of the portraits of Mom came a year or two before she died [in 2004]. My mother was a domestic worker, which I wasn't interested in when I was in college. I wasn't interested in being traditional—it was too mundane.

KB The *Mammy, How I Love You* series explores your mom's work as a domestic. You also collaborated with photographer Ernie Button (2002; pls. 66–69) to document several domestics living in the South. You were able to talk about this big aspect of her life, which you initially avoided. Did you see yourself as symbolically being your mother?

BM For these paintings, I didn't initially use my mother's image. My mother has fair skin and pretty hair. She was an attractive woman. But I really wanted to capitalize on the stereotype of a mammy figure: an overweight Black woman who was a good cook and nursemaid to white children. I dressed up in my grandma's old dresses, put on a wig and blackface, which was part of my identity as a clown. All those themes are right in line with how I felt with Renee—being in the margin, being invisible.

KB The portraits of your mother are wonderful, positive affirmations. One of my favorite portraits, *Momma* (2003–04; pl. 22), is of her sitting in a chair just as regal as she can be. I remember when you left Arizona to be near your family in North Carolina while your mother was in the

hospital dying of pancreatic cancer. There are some powerful images of your family. I think this is also the first time you haven't completely "finished" the portraits, where some of the figures are roughly drawn but not filled in.

BM I wasn't conscious of what I was doing. I was simply being an artist and choosing to keep these parts of the paintings unfinished. I found myself preferring to be an artist instead of grieving, since I could not do both at the same time. After my mom's death, Renee came to live with me in Arizona, where it was more important for me to take care of Renee than to grieve.

KB Around this time, you were also involved with the filmmakers who created the HBO documentary film *Raising Renee*, where they focused on you and the promise to your mother to take care of Renee.[2]

BM In 2002 I was at [Harvard's Radcliffe Institute of Advanced Studies] completing a fellowship. This is where I met filmmaker Jeanne Jordan, who was also a Radcliffe fellow. Jeanne was interested in making a film about me as an artist, and she began by filming me in my studio. Shortly after that my mother was diagnosed with cancer. That is when the film switched to being about me as an artist and fulfilling this promise to my mother.

KB What was it like having them following you around everywhere?

BM They didn't show me any footage for five years. I didn't know how I was being portrayed. Much of the footage was of me was in pajamas, which is how I'm most comfortable. That's the beauty of what they were doing; it was not about this perfect artist in the studio. The producers at

HBO loved the film because I appeared so down to earth.

KB The ending of the film—Renee getting herself established in her own apartment, maintaining independence, and realizing she has done well—is wonderful.

BM Renee was the poster child for the Arc of the United States [an organization serving people with intellectual and developmental disabilities]. They deemed her that because so many of their clients don't ever get to live on their own or be as independent as Renee is. She loves it.

KB I think your mom is looking down and saying, "You fulfilled the promise."

BM Renee is now sixty. She's falling more, as her seizures have increased. I know that eventually she is going to have to come back and live with me.

KB You have several portraits of your cousin Sharon. They include starkly realistic imagery that shows the ugly side of what can happen to people. In Sharon's case, you portray the experience of living with diabetes and being a double leg amputee.

BM I'd like to think of Sharon's paintings as portraying fragility or doom—what it means to be human, how humanity manifests itself in people's lives in vastly diverse ways, but they become heroic, they rise. Sharon was really the embodiment of rising from all the things she had to endure, including diabetes.

KB Sharon was not your only cousin to suffer from diabetes.

BM She had four brothers, and several of them died because of diabetes. One is in a wheelchair with a leg amputated because of it. It is heartbreaking. But I came to the realization that Sharon's only power on this earth, especially the last ten or fifteen years of her life, was being able to make the decision to put whatever she wanted to in her mouth. That was her act of power. It led to several amputations and ultimately her death.

KB One portrait, *Sharon Pushing Up Daisies #1* (2018; pl. 53), has her literally pushing up these daisies in the painting, but figuratively it is a wonderful way to pay tribute to her. You had previously used flowers as ornamentation in your portraits, but this seems different.

BM I think of the old saying: When you die you push up daisies. I really did want to use them to celebrate Sharon's life and her tenacity. She had a hard life. She took everything, including diabetes, in stride. And I can't say that I would.

KB Another figure featured prominently in your paintings is your father, Cardrew. I understand that you didn't meet him until you were seventeen. Apparently, your mother pointed out a figure standing in the kitchen doorway and said, "By the way, I need to introduce you to your father."

BM I was mad at her. I was shocked, too. How in the hell can you keep a secret like that, then just blurt it out when the man is standing at the door staring at me? My mom had apparently planned it; they apparently had stayed in touch. He was giving money to her every Christmas so that she could buy me extra gifts. One day he told Mom he was coming over and that he would introduce himself as my dad. It magnified this sense of isolation that I had felt all my life that I was different,

which was now intensified because I realized I only have half-sisters. It brought back memories of times I felt like I was treated differently.

KB Did you reach out to him and ask about getting to know him better?

BM I did initially because, when I went to college, I did not have money. I thought he would help me. He said he would, but he didn't really mean it.

KB When did you reconnect with him and begin painting portraits of him?

BM After my mother died, I decided that perhaps I should get to know him. I suspected that I had some issues around men and realized I was doing myself harm. I needed to sit and talk to him. That is how it started. He had to have surgery to remove a tumor from his head. The first painting I made of him is in the hospital.

KB The portraits of Cardrew, as in *Daddy's Birthday* (2015; pl. 46), are your affirmation of a male presence in your life. But it is also male portraiture, something that you do less often than female portraiture, which you seem to have a comfort level with.

BM I was giving a lecture somewhere, and a young Black man raised his hand and said, "When you show us your work, all I see are women. Why don't you paint men?" At that time I said, "Well, I guess I don't because there haven't been powerful men in my life journey. They have all been women." I had completed a few male portraits prior to the paintings of my father, but I believe my deep exploration of Black male portraiture started at this point.

KB Two bodies of work—the *Dear God* series and the paintings about depression—offer

compelling commentary on aspects of life that affect everyone. Is the *Dear God* series (2007–10; pls. 28–36) about the election of Barack Obama as president of the United States?

BM It started there. I was in Santa Fe, and the television announced he was going to be a candidate for the presidential nomination. My only context for this historical event was Shirley Chisholm's run for president when I was just a child. I never thought I would see this in my lifetime. I remember being so overwhelmed with joy and happiness that a brother was going to be president. So I made this series of paintings expressing how I felt. I had an image of myself that I repeated for each canvas, to hold that same sort of emotion. Then I started writing down things that were occurring daily that made me think, Is this a joke? Is this real?

KB I believe the *Depression* series (2010; pl. 38) was completed during your residency at Yaddo, the artists' retreat.

BM There was a pool of other artists in residence who came to my studio and were blown away by my work. That is where I met writer and painter Robert Storr. The *Depression* series is about my life at that time in Arizona. I was able to address that kind of sadness in what I felt like was a safe and protective place to talk about depression.

By the way, I remember you telling me, and I quote: "If you feel that bad about being in Arizona, you need to leave and never show these to anybody else. Don't show them. They are too vulnerable."

KB Okay, I did say that. But please allow me to put that statement in context. I thought these

were beautiful works about a very raw, emotional state. I erred because everyone feels that way. I come from a very dignified family where you don't show that kind of feeling in public. And maybe that was my fear.

BM The *Depression* paintings are just as relevant right now during Covid-19. I think people who suffer from depression, their head becomes so big and so heavy that they can't get it off the table. I think it is exceedingly difficult and incredibly vulnerable to share that with anybody. The saving grace is that when people see the work, they understand they are not the only one who feels that way.

KB Richard Mayhew, Faith Ringgold, and Elizabeth Lentz nurtured you and supplied an understanding of what it takes to be a good artist and professional. Did you see yourself as a nurturer for your students once you became a professor?

BM Not right away. It did not crystallize until I returned to North Carolina to teach painting at NCCU in 2007, nearly twelve years after I first taught there. John Bloedorn at Craven Allen Gallery in Durham agreed to show my work along with my students' work. I told my class they needed to choose between working hard for this special opportunity or following the class syllabus. They decided to make artwork for the exhibition. That same year I took them to New York for a week, much as Richard Mayhew did with me. Some had never flown or been to New York before. The world was opening for them. We had a wonderful time. That was the beginning for

me taking a more conscious approach to nurturing those I was teaching. Four of those students went on to graduate school to get their master's degrees, which had never happened in the history of NCCU's art department [with the exception of Beverly herself]. Lamar Whidbee was one of the students.

KB It is great to see Lamar actively working as an artist now. I believe, however, that your work in professional development predated your experience at NCCU. You were also actively doing this at Arizona State University, too. This is where students like Michael Dixon, Damian Stamer, and Claudio Dicochea were taught. You were an art professor, but you were also teaching students the business of being an artist.

BM It was important to me not to dictate what my students should do unless I was doing it myself. I was a practicing artist in addition to being a professor; I was exhibiting artworks, and I was busy applying for and receiving grants. I received some of my first big grants, like the Guggenheim and Anonymous Was a Woman, when I was at ASU. I wanted to teach my students how to be professional artists. How do you present your work? How do you give a lecture and not put everybody to sleep? How do you apply for grants? These were the things I knew were going to be extremely important for the survival of an artist; I knew they would need something to sustain themselves. It is great to be able to paint, but you must have money, too. It makes me want to cry. I didn't have children of my own. I feel like these students are my children. I feel responsible for sending them on their way as artists, giving them the tools needed to survive.

KB I remember when you were told you were a fellow at the American Academy in Rome in 2017. You called me from the airport in New York, crying. What was it like to get this prestigious opportunity?

BM I was shocked that I got the grant because it is incredibly competitive. A part of me was hoping I didn't get the grant.

KB What—why?

BM It speaks to the duality in my life. At my core I am a very private person who really enjoys routine and consistency. I am shy. Then there is this person that is more adventurous, wants to explore, and wants to have different experiences but thinks there is always a lesson. I applied for the Rome Prize because I wanted to have something on my résumé that said that I was still active—that I was not resting on my laurels. I also had never been to Italy. I had no real expectations, except that it was going to be different and new.

KB Change is hard, especially when you think about how it affects your painting. The goal is to see how this experience can further develop and enrich you with regard to your eyes and how you see things.

BM In my mind, I hadn't even gotten that far. I was thinking that I was going to Rome to represent Black people, reluctantly learn the language, and not have any comfort zones. It is the only way you grow, and thank God, I understand that much of it. There were several other African American fellows, and that made all the difference in the world. My time with them was magical because we all had the same problems. As a result, I was able to focus on painting, which

included reintroducing self-portraits in black clown makeup, as I have already mentioned, but also seeing how the differences in lighting, atmosphere, environment, and even collaboration could affect my work. *Brown Girl Memory* (2018; pl. 51) is a perfect case in point, where I collaborated with Italian artist and set designer Gaetona Casseli to create something I had not done before—namely work together on a canvas. What resulted is a fun, beautiful portrayal that combines two distinctly different aesthetics into one unified image.

KB Another collaboration you are known for is your work with dancer and performance artist Eiko Otake. How did this come about?

BM In 2019 Jodee Nimerichter, the director of Duke's American Dance Festival, asked if I would be interested in collaborating with Eiko. Jodee felt we were similar as artists and as caretakers for our families. Eiko was, at the time, living in New York but completing a residency in Colorado before heading back to Japan to care for her mother. I tried to meet with her in Colorado but was unable to fly there due to weather. We then came up with another plan; instead of her flying home to New York from Colorado, she would come to North Carolina and spend a couple of days with me.

I remember it was about 10:30 p.m. This petite Asian woman came knocking at my door. She came in, we sat, and we talked. She was hungry, so I made her some rice as we continued to talk until fairly late. We spent two or three days together, just talking about the project and its possibilities. Initially, the focus was to be about caretaking. I knew she was going to Japan four times a year to check on her mother. I wanted to visit Japan and take pictures of Eiko caring for her mother. From this, we could put together a show and talk about caregiving and its challenges. It was decided I would visit Japan the following April. Eiko called in January, however, to share that her mother was dying. If I wanted to meet her, I needed to fly to Japan immediately.

KB So the focus of the collaboration changed from caretaking to being about death—the death of a mom.

BM I book my ticket and fly to Japan, which is such a head trip. Because of the jet lag, I arrive not even knowing what day it is. I'm numb, and it feels like I might be the only Black person in the airport and all of Japan.

KB Culture shock.

BM People are staring at me, doing double takes to see a Black person. One of Eiko's students picks me up from the airport and takes me to Eiko, who is staying two hours outside Tokyo. When I finally connect with Eiko, she says her mother died just before I had arrived. We eventually get to Eiko's house, where her mother is lying in a little box close to the floor. I have to get down on my hands and knees to be at eye level with her. Eiko sits down beside me, and we pray. Orange and white rice were on a table next to her mother as a way for her to symbolically have food as she went on her journey.

KB How did the family perceive your presence there? They knew you were an artist, correct?

BM They embraced me and treated me like family. Eiko asked me to take part in their service and allowed me to take pictures. I took photographs of the ceremony and tried to document it as well as I could, much like we did at my mother's funeral. They also had me actively taking part in the ceremony, which was unlike anything I had experienced before.

KB You returned home carrying this amazing experience in your head. How did your collaboration transition from focusing on caretaking to a story about grief?

BM It became about grief because all my images from Japan were about death. I made paintings about Eiko and her mother—in particular, these images of her lying in a bed looking very frail and deceased (2019; pls. 55–57). The collaborative performance with Eiko debuted at the American Dance Festival in 2019. The paintings were already on stage before the performance. Eiko's son visited, and I remember him dropping down and weeping in front of the paintings. You realize that grief does not discriminate. I don't care if you are Black, rich, poor, Japanese, Korean, whatever. We all grieve the same. That look, that mad human look of loss is universal.

KB Eiko decided to bring you into the performance as well.

BM As a shy person, I hated it initially. The last thing I want to do is get up on a stage. She wanted us to be on stage together naked. That was not an option for me, so instead we wore simple black-and-white outfits. Eiko choreographed movements around mourning and last rites.

KB Tell me about your current work, which you have been creating in response to the Covid-19 pandemic. What was it like for you when things shut down in March 2020?

Fig. 3
Beverly McIver and Kim Boganey celebrate their December birthdays, c. 2000.

BM I currently teach painting at Duke University. Duke told us to finish the semester online. My students had left for spring break, and they didn't come back. I wrote a new syllabus; instead of focusing on how my students would complete their class paintings, I asked them to find someone and help them. I wanted them to be kind to another human being to get their grades. Some of my students were skeptical, but others completed the assignment with some amazing stories that they shared. I gave them all As because what they were doing during this time of Covid-19 was better than simply finishing a painting.

As for me, I painted. In mid-March I was praying for something to happen so that I could have a breather. I never thought it would be Covid-19. My life sometimes feels like I am on a Ferris wheel, and I cannot get off. The demands of work are continuous. When Covid-19 happened, initially I gave myself a couple of weeks to pout and mourn the loss that I could not go out. I then realized I needed to stop because Covid-19 was something I had no control over. I now had time to paint. It became wonderful.

KB You started using rope imagery in your paintings. I can see all the reasons why symbolically rope would be used, but I'm curious to hear from you how that started.

BM The rope started as a scarf. I had this silk scarf that an artist friend of mine had given me. I wrapped it around my head, covering everything. Then I had this dream. When you get quiet, your inner voice gets louder. I believe it is my angel watching out for me. That is what happened to me with the rope. I had an inner voice saying that I needed to buy some black rope, so I bought some.

I unraveled it close to the window where I had initially wrapped the scarf around my head, so that I could get the same lighting. I couldn't really see. I took some photographs. When I saw the images, I knew these were some powerful images.

KB The paintings (2020; pl. 59) are ambiguous because not everyone sees it as rope. Is that rope? Is it a noose? But they also just capture what we feel about Covid-19. During this time you also painted portraits of acquaintances so that you could remain positive.

BM I knew I wouldn't see my friends and family unless it was through a Zoom call, so I started making smaller portraits, twenty by twenty inches. They are glimpses of people I know and want to speak to, so when I walk across the room of my house, I see their faces.

KB I also recall it was about wanting to paint portraits of Black males because Black Lives Matter was happening. George Floyd and others were becoming horrifying statistics. African Americans were frustrated, and civil unrest was occurring nationwide. Life was turning upside down because, yet again, a Black man had died at the hands of a white police officer. One portrait became a poster for the organization People for the American Way.

BM The portrait is of your son Sheldon Caldwell-Meeks (2020; pl. 58). I asked him if he would take some pictures and send them to me. I had some Black male portraits, but they were of men with fair skin. I didn't have any of darker-hued Black males. Sheldon finally sent me two pictures. He said, "This is my current mood." He looked mad. The portrait was easy to capture. Michael Keegan with People for the American Way had contacted

me and asked if I would be willing to send a painting reflective of their "Enough" campaign, which would also help raise funds for the Democratic National Convention. Sheldon's portrait became the answer to that. The image was used for posters and billboards throughout Georgia, Michigan, New York, Arizona, and Wisconsin. Sheldon's portrait was perfect for the "Enough" campaign. As you know, he is rarely upset. Sheldon is eternally positive in his demeanor, but his portrait is symbolic of so many others who feel the same way and have had enough with what is happening in the United States.

KB What is next for you?

BM Renee wants to come live with me, and so does my father. They are both getting older.

KB What do you see yourself doing artistically?

BM I'm going to have to focus more on Renee, in caring for her, which is likely what I'll be painting about.

KB So this is another full-circle element, isn't it?

BM It would be nice to give back and to bring more people of color and women to the table artistically. The power of women helping other women is important. There's room for all of us. I don't have to kick you; you don't have to kick me. We will get more work done when we work together.

KB I agree. I would also say that having you as a friend has been a calling for me. We are two African American women in the arts, making the best of it and ensuring others know about the power of African American art. I am honored to be on this journey with you, to see professionally how your work has been accepted and how your work changes and evolves. But I must also mention our personal journey—the things that have happened to us that made us stronger (fig. 3). I am immensely proud of our relationship and friendship, and so happy we're able to see this exhibition become a bit of the story with regards to our journey.

1 Scottsdale Center for the Arts was the city of Scottsdale's primary venue for contemporary exhibitions until the neighboring Scottsdale Museum of Contemporary Art (SMoCA) opened in 1999. McIver's exhibition *All of Me* premiered in 1998 and was mounted at the Scottsdale Center for the Arts and remained up for several months after SMoCA opened. As a result, *All of Me* is considered one of the first exhibitions on view when SMoCA opened, even though it was physically located in the center.

2 *Raising Renee*, directed by Steven Ascher and Jeanne Jordan (Newton, MA: West City Films; HBO Documentary Films, 2011).

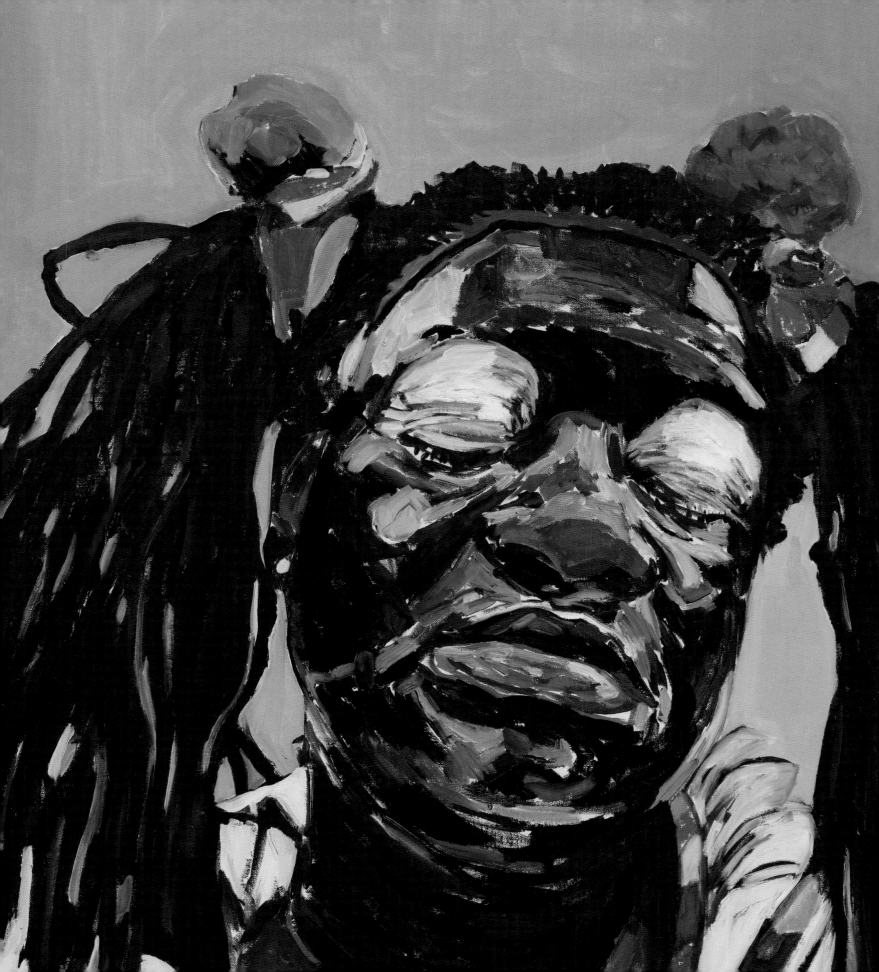

Pigments and Personas

Richard J. Powell

Among the stories that Beverly McIver has recounted about her epiphanies as an African American woman and visual artist is one that, for the purposes of thinking about her relationship to the medium of oil painting and the subjects of her art, deserves repeating. In the 1980s McIver was performing as a white-faced, costumed clown at a party for preschoolers in Greensboro, North Carolina,

> when a little white girl became attached to her. The child climbed in McIver's lap and stroked the yellow strands of her mop wig. At some point McIver's sleeve separated from her gloves, and the clown's true skin color showed through. The child pulled away in revulsion. "You're Black," she screamed at McIver and then screamed to her tiny playmates: "The clown is black. The clown is black."
>
> "It triggered a lot of feelings and contradictions for me at that time," admitted McIver. "I really wasn't aware that I was putting on this clown makeup to escape being black and that I was covering my whole body so that no one would know that I was black. Her words 'the clown is black' were so startling to me because a part of me realized that, 'Oh my, I am black.'"[1]

Setting aside the parallel shocks of recognition from the two protagonists in this story and McIver's subsequent, Fanonian racial self-analysis, I want to focus on the pivotal role that the painted face plays in this drama.[2] Concurrently a functioning mask and a visible component within a performance, McIver's white face, while part and parcel of a clown's customary costume, was incapable of concealing her racial identity and, thus, unable to achieve the suspended disbelief that clowns produce in their audiences on such occasions. While it failed McIver in this instance, the painted face proved to be a conceptual catalyst in McIver's oeuvre, forging a multidirectional bridge between subject matter, creative process, art media, pictorial composition and, perhaps most important, a work of art's essential character—or, if one extends this concept into an anthropomorphic model, an art object's persona.

Previous critics have made similar observations about Beverly McIver's delicate balancing act between the materiality of paint and the likeness-achieving stratagems of painted portraiture. As *Art in America*'s Raphael Rubinstein astutely noted, "Painting her face . . . and then making an accurate depiction of her made-up visage, [McIver brings] the language of expressionist, even hallucinatory, painting into a realist setting." Rubinstein then provocatively asked, "When McIver paints herself [is] she painting an expressionist self-portrait or a realist self-portrait of herself in 'expressionist' makeup?"[3] Of course, the answer is both, and McIver's multiple objectives point to her art's expansive reach, not only to those curious about the introspective painter and her sense of self but also to those interested in social facades, the utility of masks, and the art of theatrical makeup.

Although not "self-portraiture," the gouache and oil paintings of clowns, prostitutes, and other "painted" people by Georges Rouault offer textbook examples of what Rubinstein picked up on in McIver's work: pictures of

heavily made-up, melodramatic figures in which the artistic means—pigment-loaded tags and manual flourishes of the paintbrush—help narrativize the artwork's painted subjects, its theatrical content, and its underlying meaning. As described by literary critic Jason Price (in terms that could also explain McIver's self-portraits), Rouault's expressionistic clowns, "produced through . . . thick layers of paint, [were] his aesthetic attempt to expose—and perhaps, at times, even to condemn—the modern human soul plastically and an invitation for viewers to hunt for deeper, spiritual meaning beyond superficial appearances."[4] How ironic is it that, despite the role of the mask to conceal or camouflage, what one sees with these painted countenances are virtual windowpanes into the souls of their respective subjects, as well as artistic exposés of a subconscious, psychological kind?

Returning to McIver's anecdote about the three-year-old's pronouncement and the artist's self-reckoning, it might be more accurate to describe McIver's uses of paint as ensnared in the contrivances and symbols of ritual masquerades. These historical and contemporary face-painting practices—West African and Native American ceremonial body markings; commedia dell'arte masking in Baroque and Rococo-era France and Italy; nineteenth- and twentieth-century blackface minstrelsy in England and the United States; the stage makeup and comedic protocols of modern clowning in the West; and the extravagant cosmetics, wigs, and costuming in contemporary drag performances—are more than constitutional to McIver's work: They provide a corporeal template from which she enacts a comparable application and layering of pigments on woven and paper surfaces in service

to something that might be called portraiture but, in fact, also operates in the realms of painterly abstraction, post-Baconian gestural figuration, and a post-Black critique of identity and history.

Several paintings from the mid-to-late 1990s document McIver's early preoccupation with painted surfaces, flesh-and-blood and flat-and-fibrous. The compact, square format of *Black Self* (1996; pl. 4)—accentuated by a stitched-on square inset and a collaged paper border with the repeated words "black self"—brings viewers into McIver's pigment-saturated universe, where the brushstrokes correspond to facial features that, despite the title's blunt, racial declaration, evoke a multicolored, complicated visage. McIver's *White Face* (1996; pl. 6) depicts the clown's mien in intimate close-up and, like the piebald face in the otherwise designated *Black Self*, draws attention to these work's imprecise, descriptive titles. Oil-paint-suffused brushwork not only covers the surfaces of these works; it takes topical priority over each painting's supposed subjects, signaling in colorful daubs and impasto traces a visible, material content autonomous from the represented minstrels and clowns.

"I would learn to love clowning, dressing up and & 'being cute,'" McIver inscribed underneath her white-faced and bewigged portrait in the painting *White Girl* (1996; pl. 5). "It would be an escape for me." And yet her wide-eyed expression and the slashing brushstrokes that form her features are anything but charming; instead, they connote bewilderment and apprehension and show how this cosmetic whiteness cannot conceal or protect its wearer from an all-encompassing, ever-present social reality.

Some of the most dedicated creators of clowns in art history, from Antoine Watteau and

Henri de Toulouse-Lautrec to Pablo Picasso and Paul McCarthy, shared Beverly McIver's underlying attitude that these masked and comical entertainers were often enshrouded in a psychological darkness and artist-derived melancholy. With its roots in seventeenth- and eighteenth-century commedia dell'arte and its color-coded actors, the modern clown owes its genesis to the iconic and tragic character Pierrot, who performed in pantomime and wore a loose-fitting white shirt, baggy pantaloons, and a ghastly complexion derived from white face paint. "Since the Romantic era," writes literary critic Jean Starobinski, "the buffoon, the *saltimbanque*, and the clown have served as the hyperbolic and deliberately *deforming* images that artists have taken pleasure in presenting of themselves and of the state of art."[5] That paintings of clowns perform double, even triple, duty—to a theatrical mise-en-scène, to a clandestine artist's self-portrait, and to metaphorical commentaries on art itself—resonates especially in the genre's vaporous, white-faced varieties. Not only does this elision occur in McIver's paintings, but it also manifests itself in iconographic works like George Luks's *A Clown* (fig. 1) where, similar to McIver's *Smiling White Faces* series, the oil paint boldly asserts itself via the artist's conscious, weighty applications. In Luks's *A Clown* and McIver's *White Girl*, the ghostly pigments' illusionistic contours compete with the paintings' flatness, troubling an easy reading of these two paintings as unambiguous, plain portraiture.

Returning to McIver's *Black Self*, the artist's self-portrait with a murky overlay emanates from an entirely different context than her white-faced portrayals. According to McIver, she was inspired to portray herself in blackface after

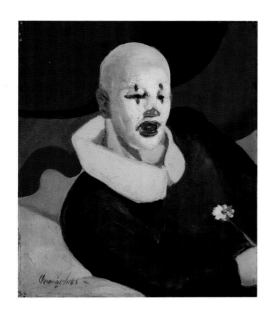

Fig. 1

George Benjamin Luks, **A Clown**, 1929. Oil on canvas; 24⅛ × 20 in. Collection of the Museum of Fine Arts, Boston; a bequest of John T. Spaulding.

seeing a French dance company's blackfaced performers in the summer of 1994. "And when I put on the blackface, it was kind of a liberation," she recalled. "I had been hiding under this white face because I didn't know I could be a black clown."[6] And yet her important series of paintings in which she first donned blackface, entitled *Good Times* (1997; pl. 7), were created three years after her discovery and in a period during which not only McIver but several prominent visual artists (e.g., painters Michael Ray Charles, Robert Colescott, and Kerry James Marshall; photographer David Levinthal; and multimedia artist Kara Walker) all incorporated blackface into their works in various ways. Recognizing in blackface a visual and conceptual device that, via an artist's ironic deployment, criticizes systemic racism through a sarcastic context or an absurdist rendering, McIver and her fellow visual satirists bravely broached this imagery for the remainder of the 1990s and well into the twenty-first century.[7] However, a key element that separated McIver from her fellow traffickers in an affected blackness were her painterly impositions within blackface imagery: conspicuous layers of pigment that, as seen in *Black Self*, covered the artworks' surfaces with an exuberance and a decidedly nonmonotone palette. "I mix Liquin with my paint to make it the consistency of room temperature butter," McIver told an interviewer. It was an admixture that, along with working from a primary palette of red, blue, and yellow, infused her blackface paintings with a translucent, subterranean glow.[8]

But McIver's insistent and iridescent impasto in these paintings did not obliterate their conceptual locus in the inglorious history of blackface minstrelsy in the United States.

Viewers of works like *Black Self, Good Times*, and similar paintings are hard-pressed to not factor into them blackface minstrelsy's racist performances, fatuous humor, and pernicious byproducts. And yet, like other contemporary artists who strategically employed these racist tropes, McIver ran the risk of an audience's reflexive aversion and rejection of her work, all in the name of an antiracist antidote and a probing, psychological statement.

"There is great ambivalence in espousing these stereotypes," wrote curator and art historian Jo Anna Isaak about Beverly McIver's blackface paintings in the exhibition catalogue *Looking Forward, Looking Black* (1999), a pioneering show that tracked this racialized incitement by several contemporary African American artists. Assimilating blackface, continued Isaak, brought McIver to "'a space of uncertainty'—the space of her own fear, rage, and humiliation, but a space of recognition and liberation as well."[9]

McIver's compensatory objective for blackface is the rationale behind *Dora's Dance #3* (2002; pl. 17), a painting in which she embodies a "liberated" retired African American housemaid named Dora she met years earlier in a Mississippi nursing home. Despite sporting the standard blackface makeup—a mouth exaggerated with red lipstick, white pigment encircling each eye, and black greasepaint on much of her face—Dora/McIver performs a character antithetical to a maid's requisite subservience. And despite her "mask" and its associations with a stereotypic blackness, the depicted persona's uninhibitedness—made visceral by her electric-blue-and-white chemise and flaming red wig—saps away such imagery's lurking venom and, in tandem with the audience's cognizance of the

actual identity of this masquerader, flies in the face of an interpretation of *Dora's Dance* as a one-dimensional, racist characterization.[10]

The fin de siècle—a time during which many contemporary artists openly explored questions of racial and gender identity in their work—was also the period when Beverly McIver pictorially submersed herself in blackface and, by way of oil-based easel painting, concocted a character that would remain a formidable presence in her work. Shown dancing, conversing with her sister Renee, carving and consuming watermelon, playing with dolls, doing routine household chores, and daydreaming, McIver circumvented the blackface minstrel's most distasteful traits by, paradoxically, being depicted undertaking everyday activities. It was as if the placement of something as racially incendiary as a blackface persona within normal, humdrum settings could deactivate the stereotype, rendering it harmless and prosaic, if not entirely inert. The artistic presence here of the ubiquitous watermelon slice—an emblem historically linked to African Americans as a stereotypic sight gag—undermines the racist joke by unabashedly appearing front and center, and, as seen, for example, in the painting *Life Is Sweet* (1998; pl. 8), making the watermelon slice, along with McIver's grinning countenance, one of several compositional elements developing a chromatic and painterly discourse on Black corporeality, figure/ground interactions, and racism's fundamental irrationality. Similar to the dramatically lit, close-up, color photographs of racist memorabilia by fellow fin de siècle artist/provocateur David Levinthal, the manner in which Beverly McIver paints her blackface alter-ego—matter of fact, sensorial, and unapologetically artful—fits

within that era's emergent post-Black mindset and its embrace of a racially informed art, minus a platitudinous, archetypal Blackness.[11]

In 1998 and 1999 McIver arguably took the blackface character to narrative extremes in each of the approximately two dozen paintings from the series *Loving in Black and White* (pls. 9–10), setting up intimate and sexually charged scenarios between her and a white man. But rather than creating salacious or abusive scenes featuring realistic actors of different races, *Loving in Black and White* conveys something else: an absurdist and unbecoming storyline that, precisely because of McIver's blackface character, eclipses a lascivious or sociological treatise and, instead, operates on a satirical and symbolic level. Like the other paintings from this period that feature McIver's blackface character, these scenes of dancing, lovemaking, and sharing watermelon are remarkable *because* of their utter mundaneness that, were if not for the housedress-wearing, Afro-wigged, blackfaced, female protagonist, would hardly elicit any concerns. And yet the average viewer is caught off guard by the introduction of this disruptive figure, whose mask actually vaults a conventional interracial narrative and labels her a conceptual "other" that, whether in the eyes of her white lover or from the audience's vantage point, ritualizes and fetishes the depicted romance.

If, as with most satires, there is a critique being made in the *Loving in Black and White* series, then one might ask who or what is being mocked or scorned? White men who love Black women? Black women who love white men? Their detractors? The racist laws that banned interracial marriage, as experienced most notoriously by the mixed-race Virginia couple Mildred and

Richard Loving? The artist herself? Possibly any or several of these, but the collective focus in the series on the fundamental human emotion of love—purposefully mediated in each painting by the enigmatic minstrel mask—suggests that all of us, as would-be participants in and spectators of such "loving" liaisons, are being criticized for our personal prejudices, our complicity in perpetuating racial stereotypes, and our hypocrisy in matters of love and desire.[12] That the metaphorical lives and loves of a racial stereotype—and the potency of the mask—might be the theoretical impetus for a series of post-Black statements was clearly behind McIver's layered, thorny narratives in *Loving in Black and White*: paintings that, according to Arizona State University Art Museum curator Heather Sealy Lineberry, "simultaneously accept, claim, and challenge the power of the social context."[13]

Blackface in these paintings commands the viewer's undivided attention, but McIver also incorporates another element that functions in an equally inveigling manner. Often in close proximity to her blackface is something—potentially anything—painted in thick red oil pigments or in a variegated reddish palette: a color and art medium that, regardless of what they depict, attract the eye and perform on their own subliminal terms. As discussed above, McIver's delineations of watermelons throughout this period are not just narrative elements signifying a racist trope: they are roseate wedges optically rupturing the dissimilar chromatic areas in which they appear. In the painting *Amazing Grace* (2000; pl. 14) McIver's blackface is placed among areas of turquoise, crimson, and brick red, with white and gold accents creating two-dimensional embellishments and contrastive elements. Or

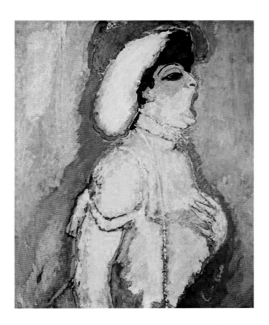

Fig. 2

Kees van Dongen, **Modjesko Soprano Singer**, 1908. Oil on canvas; 39⅜ × 32 in. Collection of the Museum of Modern Art, New York; gift of Mr. and Mrs. Peter A. Rübel.

consider *Remembering Mom* (2006; pl. 27) and its blackface persona sitting inside a deep windowsill, with a red wig, lips, floral-patterned dress, and the ruddy complexion of African American arms and legs fabricating a post-Impressionist, russet curtain around the figure's downcast expression. Like an Édouard Manet canvas, *Remembering Mom* makes the subject and medium inseparable, with this particular work's memorializing manifested through the paint's consecrative, liturgical colors brushed, clotted, and dispersed over the stretched canvas's surface.

The strength of pigment—whether experienced in an oil painting or on one's face—becomes commensurately forceful when, as in the case of Beverly McIver's paintings, the instrument *is* the statement, underscoring how these works straddle the worlds of self-portraiture, action painting, and ritual masquerade. But it is especially in the last category—a cosmetic-fashioned protocol imposing an alternative personality or a larger-than-expected social role on the art subject—that McIver's paintings complicate the conventional perceptions of the art medium. One of the most important painters of the early twentieth century, the Dutch Fauvist Kees van Dongen, tacitly understood the interconnections between his subject matter and art media, often rendering subjects such as circus performers, street hustlers, and cabaret habitués in heavily applied oil pigments that complemented their real-life use of face powder and other sartorial extravagances. For example, in van Dongen's portrait of the female impersonator–music hall singer Modjesko (fig. 2), high-key colors and conspicuous brushstrokes bring the stylishly attired belle-époque vocalist into the

sensory realm of viewers, just as Beverly McIver's portrait of the former North Carolina Museum of Art's director Larry Wheeler (in blackface–and wearing red high-heel shoes) conveys, despite the subject's public corporate exterior, his aspirational African American soul and defiant gay identity.[14]

To many observers, Larry Wheeler's mask connotes blackface minstrelsy's ugly, racist past, but to an art cognoscenti who understand how Wheeler's blackface is, first, filtered through McIver's well-documented utilizations of it herself and, second, a component that situates his self-portrayal in a drag sensibility, *Larry* (2018; pl. 54) corresponds with a whole corpus of modern and contemporary queer portraits. From Marsden Hartley and Beauford Delaney's vibrantly hued, impasto paintings of friends and lovers to the iconic 1980s–90s photographs of choreographer Bill T. Jones, artist Lyle Ashton Harris, and comedian Ellen DeGeneres, each adorned in face or body paint, the impression is that among the qualities of a queer portrait genre is the almost invisible dialogue between art, corporeality, and an implicit tactility—an aesthetic calculation that Beverly McIver summarily arrives at in Wheeler's visual rendering.[15] As for a black veneer on top of white skin that, rather than antipathy or ridicule, connotes emotional affinities, Wheeler's blackface has an antecedent in Miguel Covarrubias's Harlem Renaissance–era drawing *A Prediction to Carl from Covarrubias* (fig. 3), which shows a portrait bust of the white, Jazz Age literary critic and African American art patron Carl Van Vechten in a darkened profile and conforms in shape to a stylized Western African mask.

Among the historical models that Beverly McIver contemplated in conceptualizing Larry Wheeler's portrait was the mid-twentieth century reimaging of Diego Velázquez's *Pope Innocent X* by Francis Bacon (fig. 4). Given Bacon's contorted, bristling figure and McIver's pigment-laden rendering of Wheeler's face and body, this connection between the two might not immediately be apparent. But if one juxtaposes McIver's fluid brushwork with Bacon's swirling technique, the two approaches share a contiguous relationship to the areas of their respective canvases that, via audiences' perceptual alternations between surface and depth, refuse an understanding that pushes viewers into either an abstract expressionist (read *masculine*) assessment, or a purely tactile (read *feminine*) art experience. In other words, Bacon's *Pope Innocent X* study and McIver's *Larry* treat their role-playing, self-fashioned subjects so as to highlight their ambiguity and to emphasize the fluid, multiperspectival pathways one might take to fully engage with these subjects. What the art historian Nicholas Chare has described as the "variant touches" (i.e., impasto smears, flush pigmented expanses, trailing brushstrokes, linear scrawls, etc.) in Francis Bacon's paintings have their counterparts in McIver's various handlings of Wheeler's figure (for example, in the face, short and fractured brushstrokes, while in parts of the torso, low-relief, unpainted, and collaged areas).[16]

Painted splendor was not only codified in Beverly McIver's portrait of Larry Wheeler. On the occasion of a 2018 North Carolina Museum of Art gala honoring Wheeler upon his retirement as the museum's director, McIver photographed an artist's model whose painted body visually corresponded to a painting in the museum's collection, *Judith and Holofernes* by Kehinde Wiley. One of several decorated bodies, or "live" artworks, situated throughout the museum during that celebration, the model and the illusion she created—her full body paint and flowery designs aligning with *Judith and Holofernes's* two-dimensional patterning against a black background—inspired McIver to return to Black corporeality (which she had moved away from since 2005) and to expand the blackface paradigm into something at the same time figural and abstract. *Black Girl Beauty* (2018; pl. 52), the first in a series of related canvases, placed a lissome Black female silhouette, festooned with colorful and expressionistic botanical motifs, against a gray and pastel-colored expanse. Liberated from tenuously referencing facial and bodily details, McIver sought in *Black Girl Beauty* to more broadly contemplate racial Blackness, femininity, and an aesthetic ideal, all within her ongoing interest in painted exteriors and their capacity for revealing submerged truths, inner anxieties, and historical realities. Although approximately twenty years apart, McIver's *Black Girl Beauty* and the 1996–97 *Black Self* come from common wellsprings: on a formal level, they are exegeses on the artist-instigated semiotics of oil pigments and their chromatic interactivity; on a conceptual level, they are revaluations of self-worth via the peculiar interpolations of racism, Black pride, and humanity's universal standards for beauty.

Clown Portrait (2018; pl. 50) evidences how much Beverly McIver had reconciled her earlier consternations around self-image and her public identity while still utilizing the signifying potential and ocular energy of the painted body. Also known as *Halloween in Italy #2*, the large portrait bust harkens back to the earlier

Fig. 3

Miguel Covarrubias, **A Prediction to Carl from Covarrubias**, n.d. Beinecke Rare Book and Manuscript Library, Yale University, New Haven, CT.

Fig. 4

Francis Bacon, **Study after Velázquez's Portrait of Pope Innocent X**, 1953 [CR 53-02]. Oil on canvas; 68⅜ × 54⅞ in. Nathan Emory Coffin Collection of the Des Moines Art Center; purchased with funds from the Coffin Fine Arts Trust.

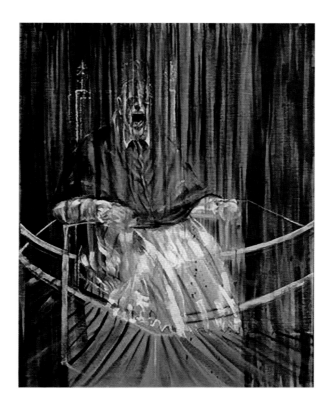

clown paintings but, unlike its predecessors, it exudes a cerebral quality (owing to the figure's closed eyes, slightly averted head, and the painting's ethereal, pale olive-green and ochre upper register). Instead of a yellow mop or a red wig on the clown's head, a profusion of shoulder-length, twisted black locks in two ponytails brings African American cultural authenticity to the portrait.

Although more coincidental than intentional, the gaudy hair ornaments, the multicolored bits of visible clothing, and the motley patches of different pigments comprising the figure's mostly black face in McIver's *Clown Portrait* recall the attributes of the commedia dell'arte character Harlequin: a trickster-servant role in these early-modern masked comedies (and a dramaturgical foil to the other stock character, Pierrot), most often depicted in a polychrome, diamond-

patterned costume with a brown or black face. But this visual correspondence between the classic Harlequin and McIver's Afrocentric clown perhaps has more corroborating it than one might initially assume. In his book *Figures in Black: Words, Signs, and the "Racial" Self* (1989), Henry Louis Gates Jr. makes compelling links between Harlequin's African origin myth and the character's Anglo-American metamorphosis into a racially stamped blackface minstrel. Additionally, Gates discusses how, in some commedia dell'arte dramas, Harlequin "could simply point to one of the black patches on his suit and become invisible"—a slight-of-hand that, at least in terms of racial inconspicuousness, McIver also sought through her early masquerades.[17] But as seen in the pigment-rich and psychologically transcendent *Clown Portrait*, another kind of racial occlusion was also conceptually possible.

The thematic identification with Harlequin and his portrayal in countless paintings by Picasso serves as yet another comparison with McIver's *Clown Portrait*. Picasso's *Harlequins*—from his gaunt, emotionally contemplative performers to his more decorative, cubist creations—meet McIver's *Clown Portrait* on both artistic fronts, but it is especially in Picasso's abstract Harlequins that one intuits a genuine meeting of the minds. Like McIver's strategic use of blackface, one finds in Picasso's interwar, cubist Harlequins a preponderance of black pigment, whether referring to Harlequin's mask or appearing as a contrastive component on this character's checkered exterior. This constitutive blackness, in either instance superficially discernable and aesthetically affecting, functions metaphorically to create a kind of anticlown: a ceremonial harbinger of gravitas and truth

rather than of humor and subterfuge. It is also interesting that, like McIver's subjects, Picasso's abstract Harlequins are painterly, their built-up oil-paint surfaces forming much of their evidentiary import and, subsequently, inviting viewers' careful consideration and judgment.[18]

This critical maneuvering between Beverly McIver and a roster of modern painters, between white-faced clowns and blackface minstrels, between her subject matter and the materiality of her art, and between her retinue of colors and their possible connotations in art and life might confuse those unaccustomed to navigating overlapping art histories and contradictory artistic motivations. Similarly, when an artist chooses to paint herself with explicit biographical references and racially fraught emblems, spectators are inclined to read her work exclusively through these narrational add-ons and ignore the work's core elements. "The painting, the act of painting and the act of applying oil paint to the canvas is sort of a complete experience in itself," McIver told a student at Arizona State University in 2000. "Even if you don't make anything, even if what you make is trash, the process of making [an] oil painting is wonderful and sensuous." What McIver doesn't reveal here is her work's inexplicable, almost invisible migration from the sensuous to the emotionally expressive and, then, from the emotionally expressive to something representational, figurative, and evidentiary.

The eminent artist, educator, and color theorist Josef Albers probably would have concurred with Beverly McIver's separation of painting's "powers," although he stated it somewhat differently: "[In] painting, the physical properties of color are of less interest than the psychic effect. What color is, is of less concern than

what it does. Painting is color acting. The act is to change character and behavior, mood and tempo. An actor makes us forget his name and individual features. He deceives us and functions as another than himself."[19]

Beverly McIver's prodigious output over the last several decades, especially her self-portraits and pictures of selected individuals, brings Albers's notions of active, efficacious colors to life, literally. Significantly, she accomplishes this theoretical concurrence via paintings of painted actors whose roles and personas are not so much channels for deception as they are the routes for ascertaining and gaining a greater appreciation for their subjects' not-always-uplifting, but revelatory, true colors.

1 Cathy Gant-Hill, "Portraits," *News and Record* (Greensboro, NC), November 15, 1996.

2 Beverly McIver's revelatory encounter with the white child strongly resonates with the Martiniquan psychologist Frantz Fanon's eye-opening chance meetings with whites on the streets of Paris, as recounted in Frantz Fanon, *Black Skin, White Masks* (New York: Grove Weidenfeld, 1967), 109–13.

3 Raphael Rubinstein, "The Grieving Clown: Beverly McIver's Recent Paintings," in *Beverly McIver: Paintings* (Greensboro: University of North Carolina at Greensboro, Weatherspoon Art Museum, 2004), 17.

4 Jason Price, "George Rouault's (Un)popular Clown Paintings," *Early Popular Visual Culture* 16, no. 3 (2018): 262.

5 Jean Starobinski, "The Grimacing Double," in *The Great Parade: Portrait of the Artist as Clown*, ed. Jean Clair (New Haven, CT: Yale University Press, 2004), 16–17.

6 Beverly McIver, as quoted in Glenn McNatt, "Facing Up to Disturbing Racial Stereotypes," *Baltimore Sun*, March 9, 2003.

7 I discuss this fin de siècle phenomenon in a chapter entitled "The Minstrel Stain" in Richard J. Powell, *Going There: Black Visual Satire* (New Haven, CT: Yale University Press, 2020), 102–54.

8 "Portrait of an Artist: Beverly McIver," *Face to Face* (blog), National Portrait Gallery, Smithsonian Institution, Washington, DC, accessed December 16, 2020, https://npg.si.edu/blog/portrait-artist-beverly-mciver.

9 Jo Anna Isaak, ed., *Looking Forward, Looking Black* (Geneva, NY: Hobart and William Smith Colleges Press, 1999), 5.

10 Rubie Britt-Height, the Mint Museum's director of community relations, shares McIver's story about encountering Dora and explains McIver's symbolic use of blackface: The Mint Museum, *"Dora's Dance by Beverly McIver for Interactive CLT,"* video, 1:04, posted May 20, 2020, https://www.youtube.com/watch?v=JWXHoiTM73o.

11 For a discussion of David Levinthal's photographic sleight-of-hand with stereotypic imagery, see Manthia Diawara, "The Blackface Stereotype," in *Blackface*, by David Levinthal (New York: Arena Editions, 1999), 7–17.

12 Mildred and Richard Loving were the plaintiffs in the US Supreme Court case *Loving v. Virginia, 388 U.S. 1* (1967), in which their 1959 conviction—for violating Virginia's Racial Integrity Act of 1924—was overturned and Virginia's law was deemed unconstitutional. For an earlier and very satirical look at interracial relationships, see *The Story of a Three-Day Pass*, directed by Melvin Van Peebles (1968; Santa Monica, CA: Xenon Pictures), DVD. Both the historic legal case and Van Peebles's hilarious take on these liaisons illustrate the longstanding topical currency of McIver's comparable artistic interrogation.

13 Heather Sealy Lineberry, "Beverly McIver," in Isaak, *Looking Forward, Looking Black*, 37. The history of McIver's *Loving in Black and White* series has yet to be thoroughly documented or written. Conceived while McIver was living and working in Arizona in the late 1990s, the depicted scenarios for the paintings were actually staged and photographed by McIver and friends in Oakland in 1998 and painted that same year and well into 1999 at McIver's studio in Chandler, Arizona. Emanating from McIver's self-analyses

around interracial relationships and racial and gender misperceptions, *Loving in Black and White* was briefly shown later in 1999 at the Chandler Center for the Arts' recently opened Vision Gallery, but within a matter of days their controversial subject matter prompted gallery staff to deinstall the paintings. With the exception of one or two, many of the paintings in the series have not been shown since 1999, and the majority remain in storage. Beverly McIver, interview with the author, December 9, 2020.

14 Anita Hopmans, *The Van Dongen Nobody Knows: Early and Fauvist Drawings, 1895–1912* (Rotterdam: Boijmans Van Beuningen Museum, 1997), 238–39, 306–07.

15 Queer portraiture has been examined by art historians from numerous vantage points, but two studies have been especially useful in thinking about McIver's portrait of Larry Wheeler: Susan Fillin-Yeh, "Dandies, Marginality and Modernism: Georgia O'Keeffe, Marcel Duchamp and Other Cross-Dressers," *Oxford Art Journal* 18, no. 2 (1995): 33–44; and Jonathan D. Katz and David C. Ward, *Hide and Seek: Difference and Desire in American Portraiture* (Washington, DC: Smithsonian Books, 2010). The three photographic portraits referenced here are: Tseng Kwong Chi and Keith Haring's *Bill T. Jones* (1983); Lyle Ashton Harris's *Americas* series (1987–88); and Annie Leibovitz's *Ellen DeGeneres in Kauai, Hawaii* (1997).

16 Nicholas Chare, "Sexing the Canvas: Calling on the Medium," *Art History* 32, no. 4 (September 2009): 684.

17 Henry Louis Gates Jr., *Figures in Black: Words, Signs, and the "Racial" Self* (New York: Oxford University Press, 1989), 51.

18 A 2008 exhibition at the Complesso del Vittoriano in Rome explored in depth Picasso's career-long fascination with this pivotal commedia dell'arte character: Yve-Alain Bois, ed., *Picasso Harlequin, 1917–1937* (Milan: Skira, 2008).

19 Josef Albers, *Josef Albers—Formulation: Articulation* (London: Thames & Hudson, 2006), portfolio II, 29.

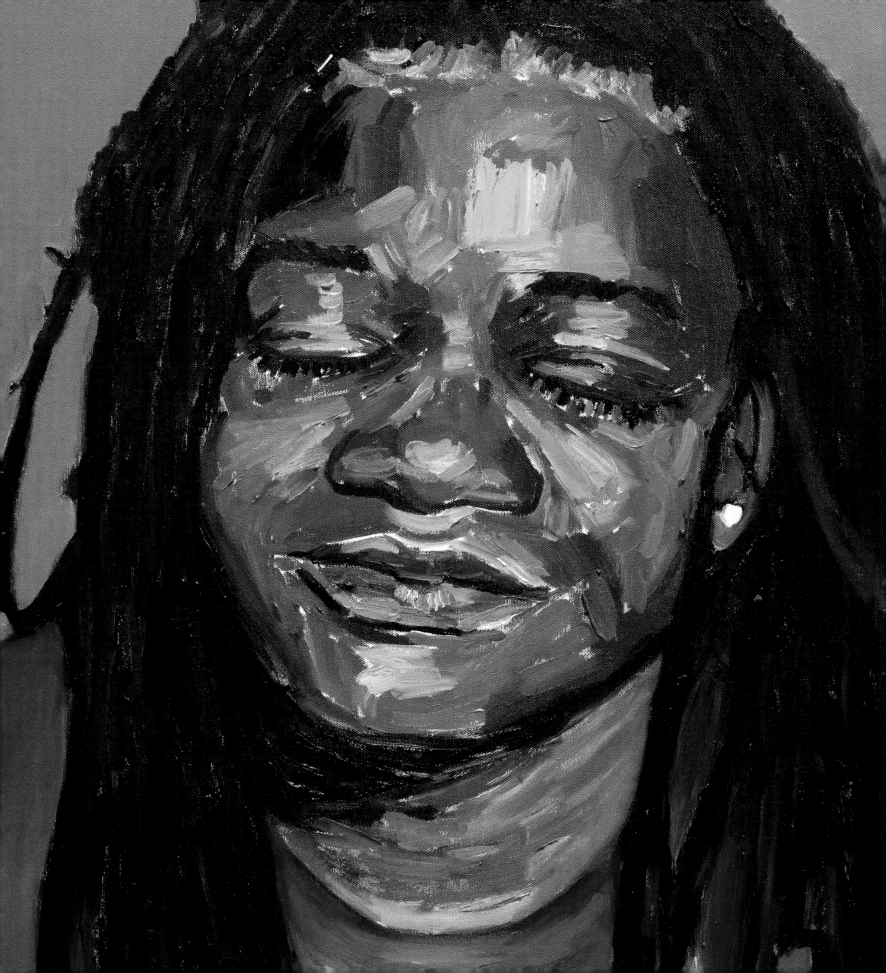

Beverly McIver: Self-Portraits in Multiple Perspectives

Michele Faith Wallace

It was during one of my mother's annual garden parties that Beverly McIver first told me of the spirit-crushing racism that nearly derailed her career as an artist (see "A Conversation with Beverly McIver," pp. 11–23). She shared this life-shaping narrative from her graduate-school years with me in 2017, at the party where she was the guest of honor as the recipient of a Distinguished Artists and Scholars Lifetime Achievement Award from the Anyone Can Fly Foundation, which was founded by my mom, artist Faith Ringgold.[1] At that point, given Beverly's glowing success and beautiful paintings, it was hard to imagine anyone ever treating her poorly.

Her story particularly struck me because when it happened, back in 1990, Beverly was twenty-nine. At that age, she was not yet in touch with her capacity for rage and disappointment. Perhaps that was the real point of such an experience. I was twenty-nine years old when I had my first mental breakdown. Ever since then, I pay particular attention to anyone who is twenty-nine and struggling because I am convinced it is a moment of particular fragility, especially for women. Generally, one's life changes at this point for the better, although it might not feel like it at the time. So, I can just imagine Beverly's despair at such a fragile point in a woman's life, when she had no way of judging whether she could, in fact, become an artist. It was then that she first connected with my mother.

Beverly met Faith the following fall, in 1991, after venturing back to Penn State to attend a lecture Mom was giving there. That's when things started looking up. In Faith, Beverly saw what she wanted to be: a working Black woman artist, articulate, beaming with self-confidence, saying what she wanted to say (speaking truth to power), and doing what she wanted to do. That evening Beverly found an opportunity to show my mom her work and tell her about things she had experienced. Faith readily confirmed her worse suspicions and her best instincts. Yes, racism was at play. And, yes, Beverly was, in fact, a promising young painter on track to becoming a genuine somebody. And then Faith did what good mentors do—which, as a feminist, she has done for countless Black women artists all her life; so many Black students never get this and don't even know they are going without— and suggested that Beverly might like to work as her assistant for a residency at the Atlantic Center for the Arts Center in New Smyrna Beach, Florida, in the spring of 1992. Beverly got travel money from her dean at Penn State, and Faith got Beverly painting again.

Beverly used a sewing machine to incorporate some of Faith's quilting techniques into her work. Most notable for me is a portrait of Faith and her granddaughter (fig. 1); we called her Baby Faith, and she was then ten years old. I didn't even know there was a Beverly then, but eventually this portrait of Baby Faith landed in my hands. The more I looked at it, the more I began to suspect there was, in fact, a third figure in the image. It was blurry and smudged out. I spent years contemplating that smudge, wondering about the person who had made this work. I went back and forth. Was it a mistake? I grew more and more certain it was no mistake. As it

happened, this was my first exposure to one of Beverly's key techniques of self-portraiture, a kind of self-erasure. Yet this predates all the work I would subsequently know as Beverly's, and it belonged to the phase of work she did while still an art student finding her way.

Following the early years of her professional career as an artist, paintings like *White Face* (1996; pl. 6) introduce close-up renderings of Beverly in her white clown makeup, red nose and cheeks, and eyes with blue circles. In *White Girl* (1996; pl. 5) she added text that makes explicit the role the clown club played seventeen years earlier in her emerging self-image, as well as how we viewers should read these images.

By 1998 Beverly had made the transition to blackface, which, she explained, was a way of adapting her clown persona to Blackness. She began to insert props into her paintings, most notably white gloves, a wig, and, in *Life Is Sweet* (1998; pl. 8), a slice of watermelon. I immediately interpreted this to mean that both watermelon and life can be sweet no matter how Black you may be.

I have always loved watermelon, too. My memory of its sweetness goes back decades to lunchtime at the New Lincoln School in New York in the 1960s. When watermelon was served there, I could go around to the few Black kids in my mostly white private school and scoop up all the watermelon. They wouldn't touch it because of the part watermelon played in stereotypical images of Blacks over at least a century. Indeed, very early silent films sometimes featured Black people in watermelon-eating contests. Maybe I didn't have the same understanding as other Black kids of what watermelon was supposed to mean at the time (and had to go to graduate

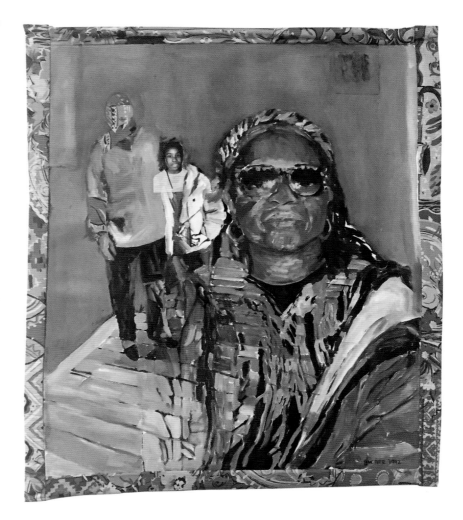

school in cinema studies to find out). In my mother's branch of our family, we had no existing ties to the South. For some reason, my mother's dad and mom—Andrew Jones, born in 1901 in Tampa, and Willie Posey, born in 1903 in Palatka, Florida—hadn't left the South until they were in their teens and migrated to Harlem. They never took their children south, and the idea of

Fig. 1

Little Faith and Me, 1992. Oil and collage on canvas, with fabric border; 45 × 36 in. Collection of Faith Ringgold, Englewood, NJ.

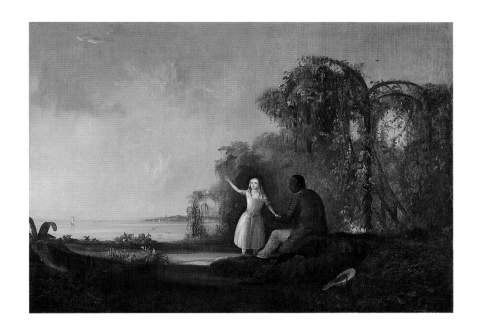

taking us grandkids was never even broached. Of course, this may have had something to do with the violent racism in the South—a story told by the Black press in graphic pictures, so every Black person above a certain age had seen the images and heard the stories.

But the fact is that watermelon is an African fruit, and I always knew it was right for me. Of course, in our Harlem household and at the Black summer camp my sister and I attended as children, watermelon was served as often as possible. In the summer, Southerners would drive up to the city with a truckload of watermelons and sell them on street corners, keeping Harlemites well supplied with this delicious fruit. They had black seeds then, which I loved. It is difficult to find one today as delicious as those were.

The official line on the use of the iconography of racial stereotypes, regardless of the race of the artist, is that they are a bad thing. But, in fact, many important African American artists deploy such iconography, from Betye Saar to Robert Colescott to Kara Walker. Indeed, it seems almost impossible to be an African American visual artist without taking a shot at such stereotypes by one

means or another, as Black stereotypes in visual form (cartoons, caricatures, genre paintings) predate by at least a century the prominence of African American artists as purveyors of Black subject matter.

Therefore, the very act of becoming a Black artist invariably includes a lusty swipe at the bedrock of racial stereotypes, even among the most cautious, lyrical, reserved, and indirect of African American artists. They have had little choice but to operate along a continuum that can range from total "invisibility" to a non-negotiable Blackness. Examples of mobilizing "invisibility" can range from Joshua Johnston's eighteenth-century portraits of whites to Robert Duncanson's conventional landscapes, including *Uncle Tom and Little Eva* (fig. 2), to the many prominent African American abstract painters who signal their race via all sorts of uncanny measures. For stark, absolute Blackness, we can turn to such painters as Kerry James Marshall and Amy Sherald, with their use of dense and gravelly Black skin tones; my mom's use of the words "Nigger" and "Black Power" in her paintings of postage stamps and flags; and conceptual artist David Hammons's *Esquire (John Henry)*, in

which tufts of black hair (gathered from barber-shop floors) are applied with sweat to a stone balanced on a steel railroad tie.[2]

Another way of talking about this level of invisible aesthetic unity in African American art is what I have previously referred to as the "African Sublime."[3] It describes a unity that transcends medium, style, and genre since we took that ride on those slave ships. It's like the blues. It isn't pretty or fetching, but it's fierce, and Beverly's work has it in spades.

Studying Beverly's evolution—from a girl growing up poor in the South in the 1960s to the strong, fascinating creature she has become at fifty-nine years of age—has made it possible for me to see her story unfold in ways evocative of the written artistry of the late Toni Morrison. I'm reminded of a character in Morrison's *The Bluest Eye* (1970).[4] In the book, Pecola's tragedy is that her mother and father, ground down by lives of poverty and racial discrimination, have grown to hate one another—and their children as well. Pecola's mother works as a maid, like Beverly's mother did. Unlike Beverly's mother, Pecola's mother loves the little white girl she tends more than her own. In a highly dramatic scene, Pecola visits her mother at her job and accidentally upsets a freshly baked blueberry pie in the process, only to be chased from the kitchen by her mother for making the little white girl cry.

Such scenes evoke for me Beverly's paintings of a mammy tending to white children. Beverly paints herself in blackface and wig, waiting on a little white girl. But when I consider the reality of Beverly's life in contrast to Morrison's creation, I can see that the poetry of the novel emanates precisely from the way in which a fairly common sociological situation has been fictionalized. Beverly's scenarios are fictional as well—or rather, one might say Beverly has fictionalized by staging. Not only are characters sometimes flat, but scenarios can be rendered flat as well. Where Morrison wished to convey the soul-killing process of people caught in inescapable roles, Beverly re-creates the drama with her own unique use of iconography, which enables us to clearly see that it is our own Beverly behind the mask.

Beverly's work fits comfortably within the traditions of American figurative painting, as seen in the works of Philip Pearlstein, Alex Katz, Chuck Close, and Irving Sandler. She fits well within the tradition of American feminist artists, such as Alice Neel and Cindy Sherman. Where she belongs as an African American artist is a bit harder to say because, although lots of African American artists are painting portraits at the moment, none has thus far shown the imagination, daring, and ingenuity of Beverly in doing so. And yet Beverly's work resonates to the bone for me as African American. And I can't wait to see where she takes it next.

1 The Anyone Can Fly Foundation was founded by Faith Ringgold in 1999 with the mission of expanding the art establishment's canon to include artists of the African Diaspora; see https://anyonecanflyfoundation.org. Ringgold's interview with McIver on that day in 2017 can be seen at Faith Ringgold, "Beverly McIver Interview, June 25, 2017," video, 1:17, posted June 26, 2017, https://www.youtube.com/watch?v=OH8PejCIijA.

2 See Daniel Soutif, *The Color Line: Les artistes africains-americans et la segregation, 1865–2016* (Paris: Musée du Quai Branly; Flammarion, 2016); David Driskell, *Two Centuries of Black American Art* (Los Angeles: Los Angeles County Museum of Art; New York: Knopf, 1976), 35–43; and Richard Powell, *Rhapsodies in Black: Art of the Harlem Renaissance* (Berkeley: University of California Press, 1997).

3 I coined the phrase "African Sublime" in an essay of that title in *30 Americans: Rubell Family Collection* (Miami: Rubell Family Collection, 2008), 24–29, 91.

4 Toni Morrison, *The Bluest Eye* (New York: Holt Rhinehart & Winston, 1970).

PLATES

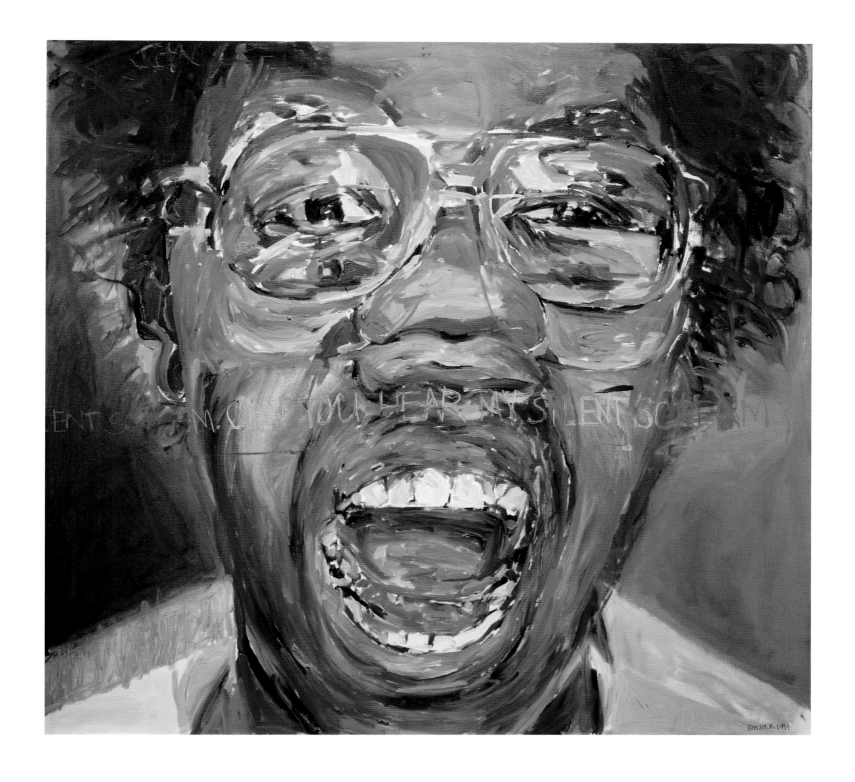

Plate 1 *Can You Hear My Silent Scream*, 1994. Oil on canvas; 38½ × 40½ in.

Plate 2 *My Pretty Red Outfit*, 1994. Oil on canvas; 22 × 28 in.

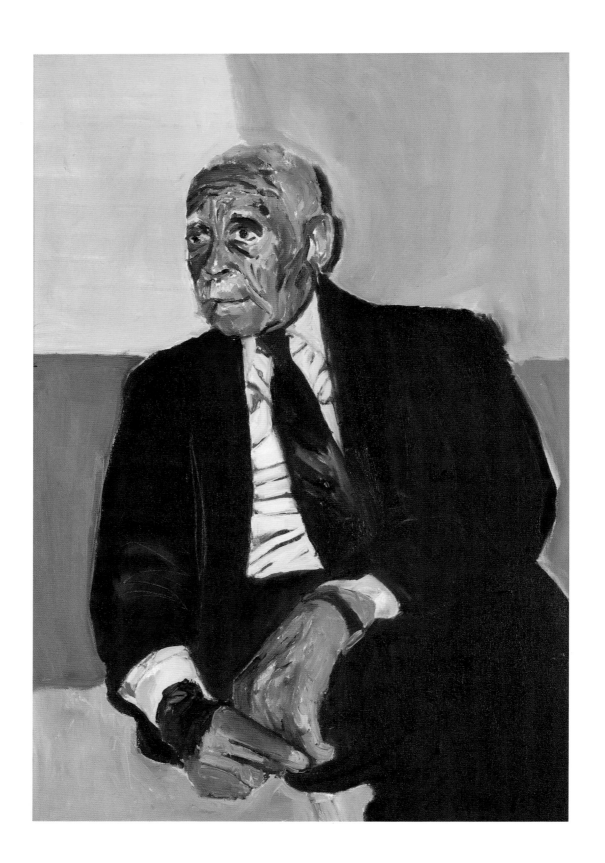

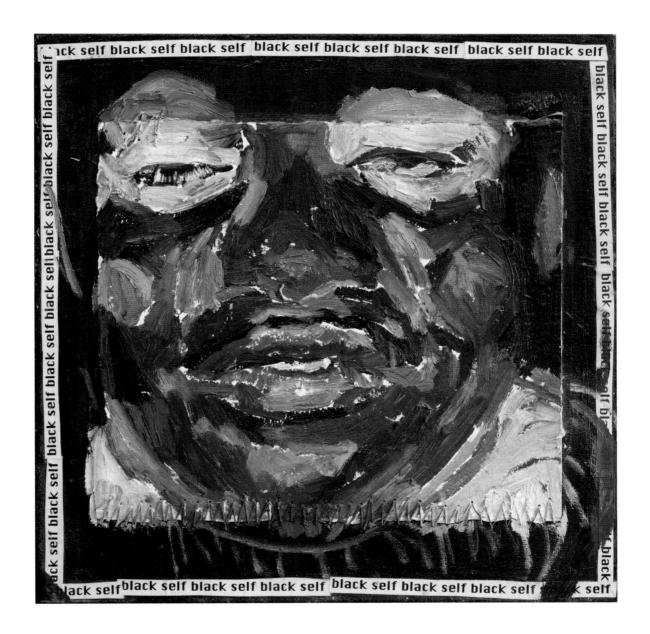

Plate 3 *York Garrett*, 1994. Oil on canvas; 33½ × 23 in.

Plate 4 *Black Self*, 1996. Oil on canvas, collage; 17¼ × 17¼ in.

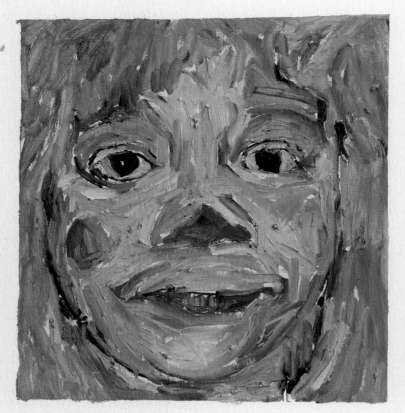

In 1979 I join the Grimsley Sr. High School Clown Club. My sister Roni & I were two of the few blacks in the club. We were partners. My sister would graduate that year, leaving me behind as a clown member. I would ~~learn~~ learn ~~come~~ to love clowning, dressing up & "being cute". It would be an escape for me. It was a time that I could be myself without judgement. As a clown I wasn't black, I wasn't poor a wasn't a woman, and I wasn't from the projects. It was what I was a white girl!

BMCIVER
1996

Plate 5 *White Girl*, 1996. Oil on paper with ink text; 39 × 30¼ in.

Plate 6 *White Face*, 1996. Oil on paper; 22 × 10 in.

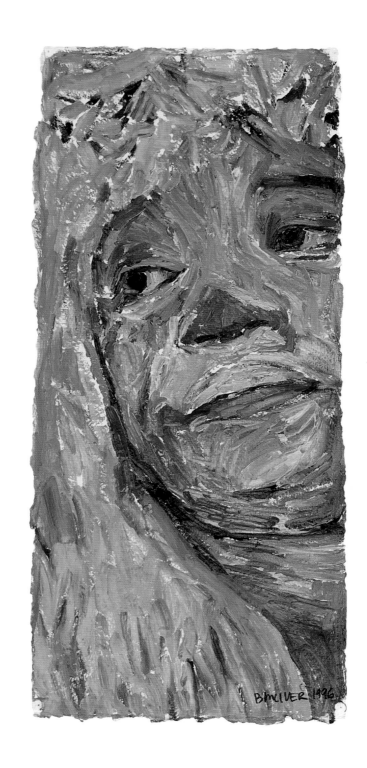

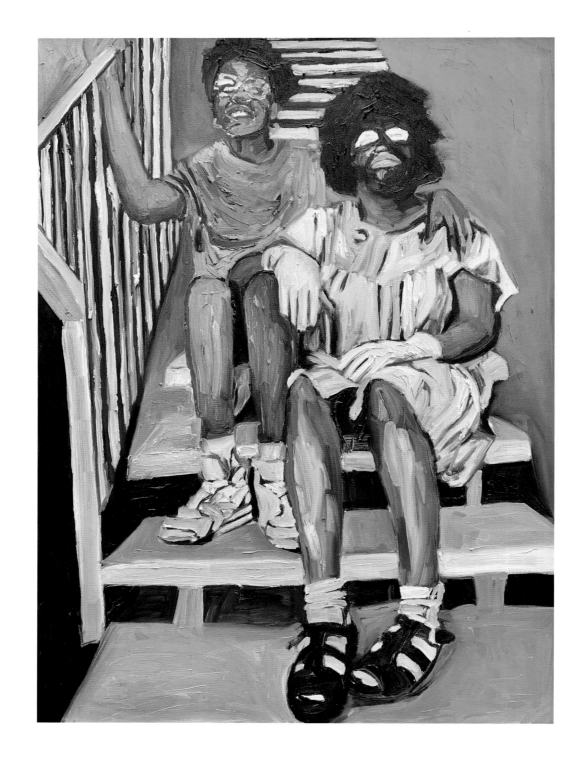

Plate 7 *Good Times #3*, 1997. Oil on canvas; 30 × 20 in.

Plate 8 *Life Is Sweet*, 1998. Oil on canvas; 48 × 36 in.

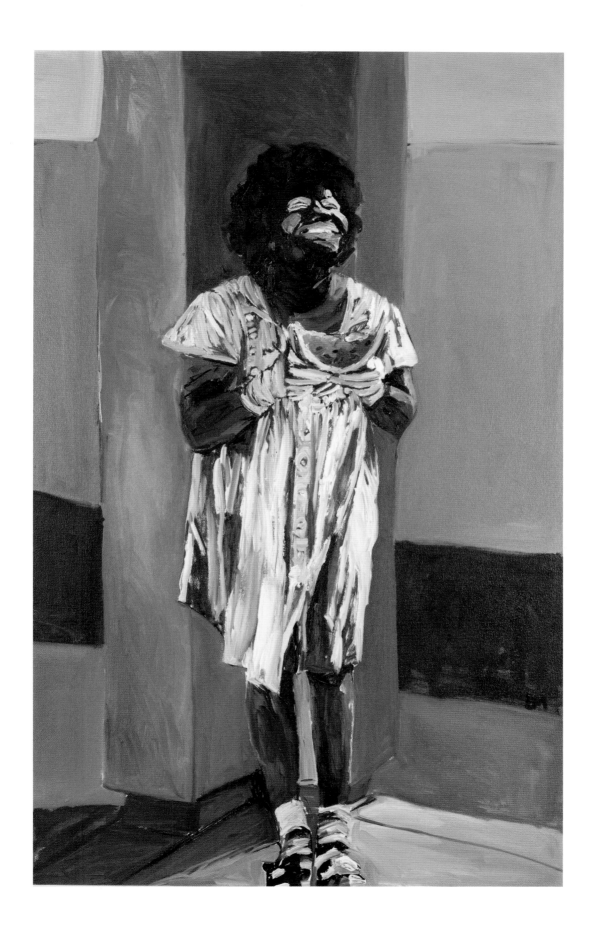

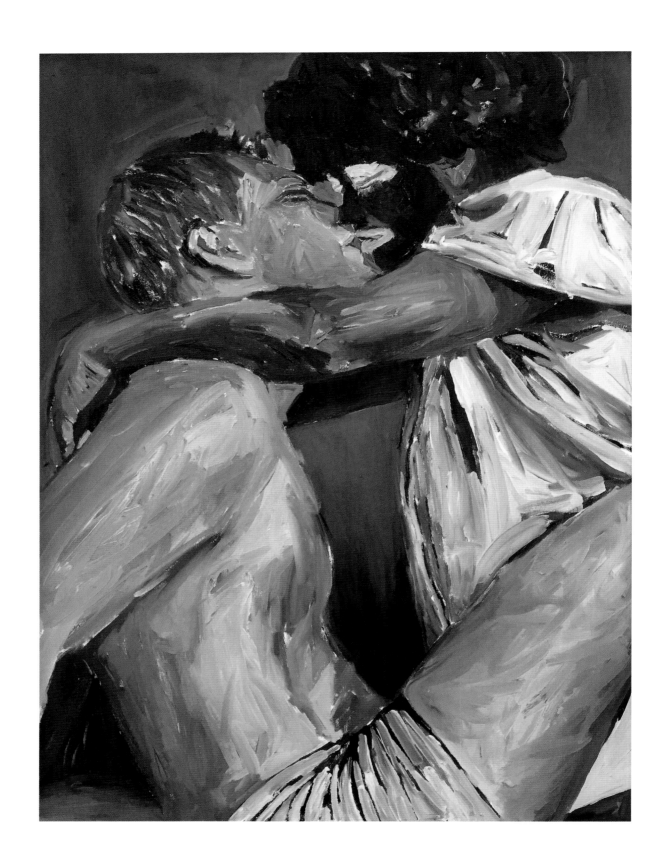

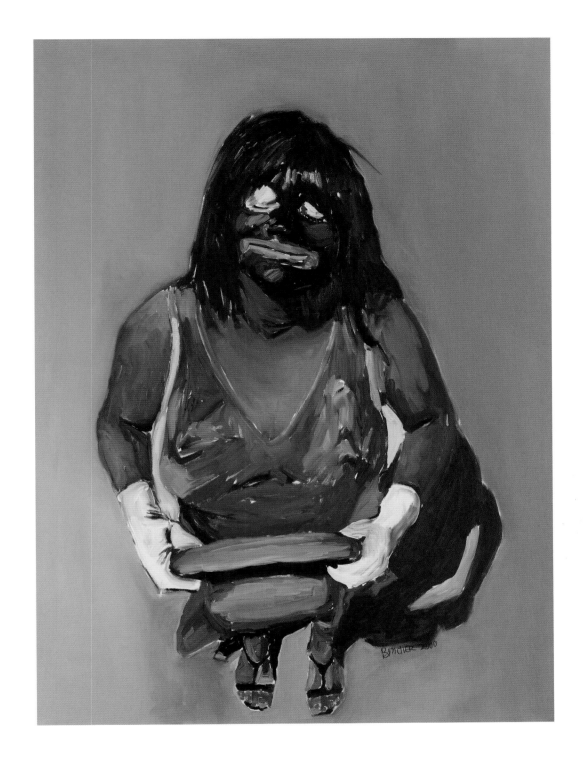

Plate 13 *Jumping for Joy*, 1999. Oil on canvas; 60 × 49 in.

Plate 14 *Amazing Grace*, 2000. Oil on canvas; 48 × 36 in.

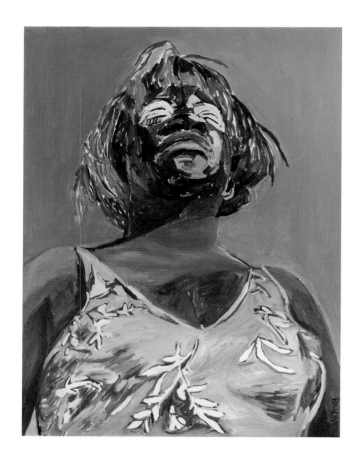
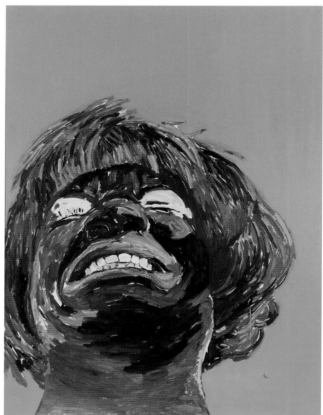

Plate 15 *Five Days of Feeling*, 2002. Oil on canvas; 49 × 180 in. overall.

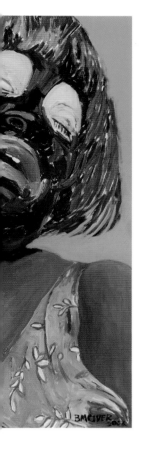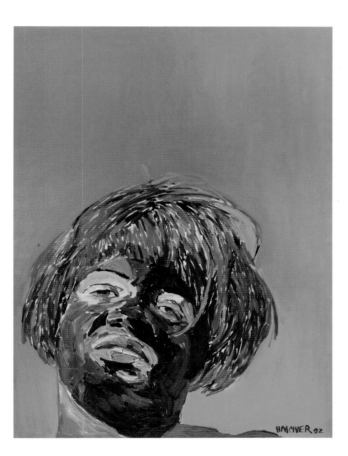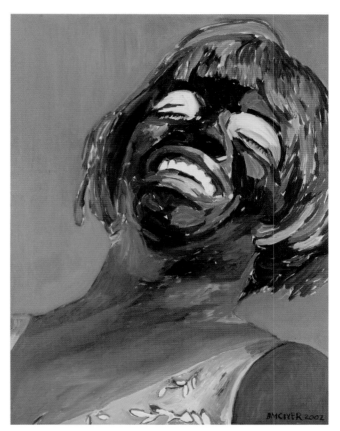

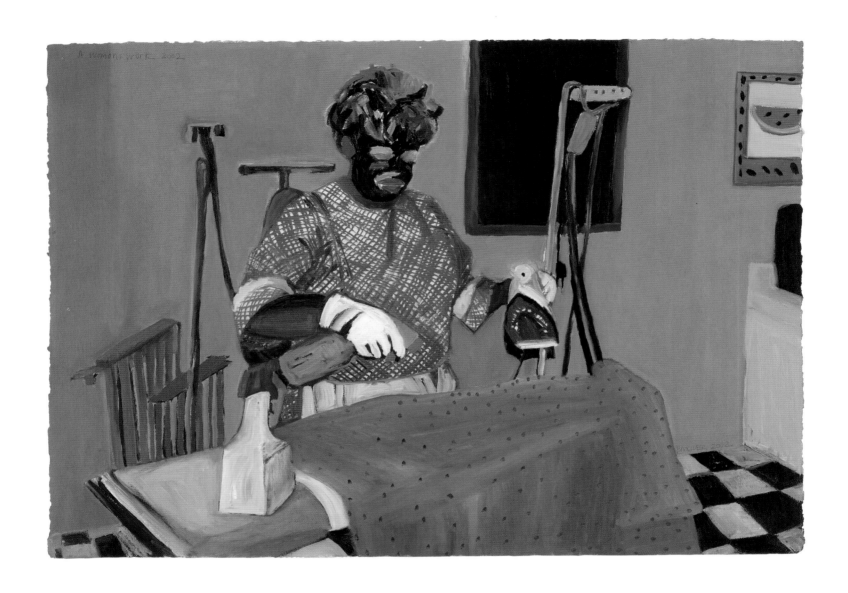

Plate 16 *A Woman's Work*, 2002. Oil on paper; sheet: 28 × 42 in.

Plate 17 *Dora's Dance #3*, 2002. Oil on canvas; 60 × 48 in.

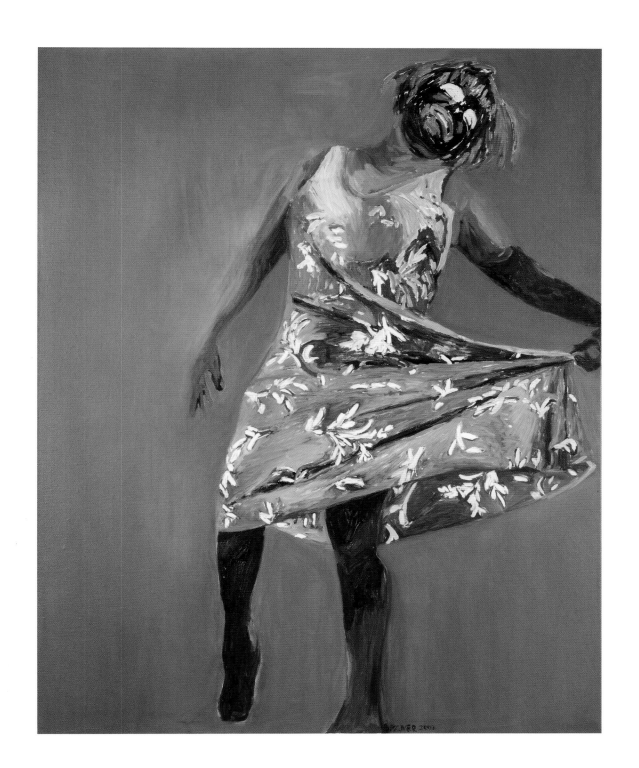

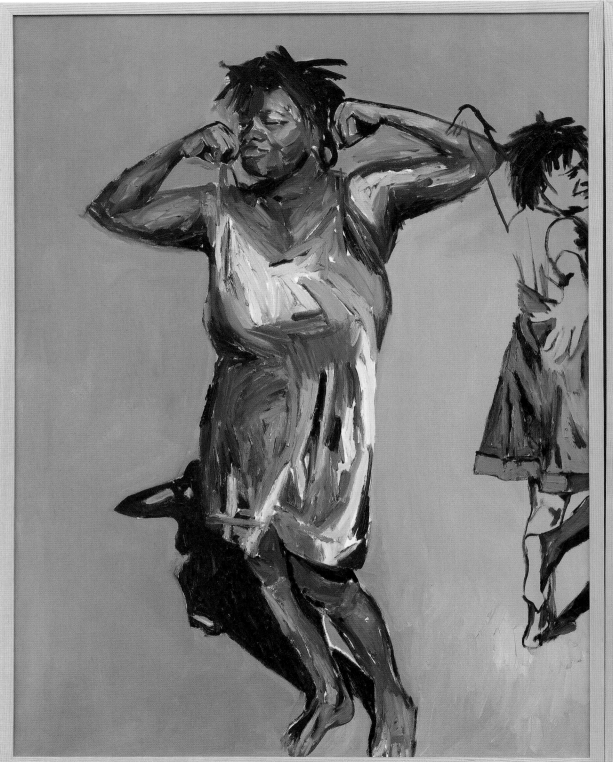

Plate 18 *Dancing for My Man*, 2003. Oil on canvas; 48 × 96 in.

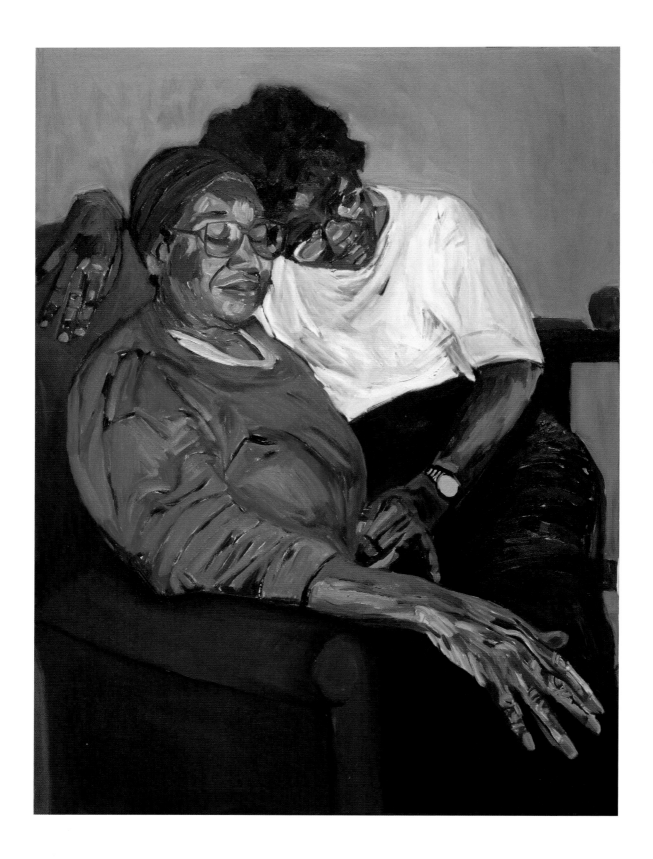

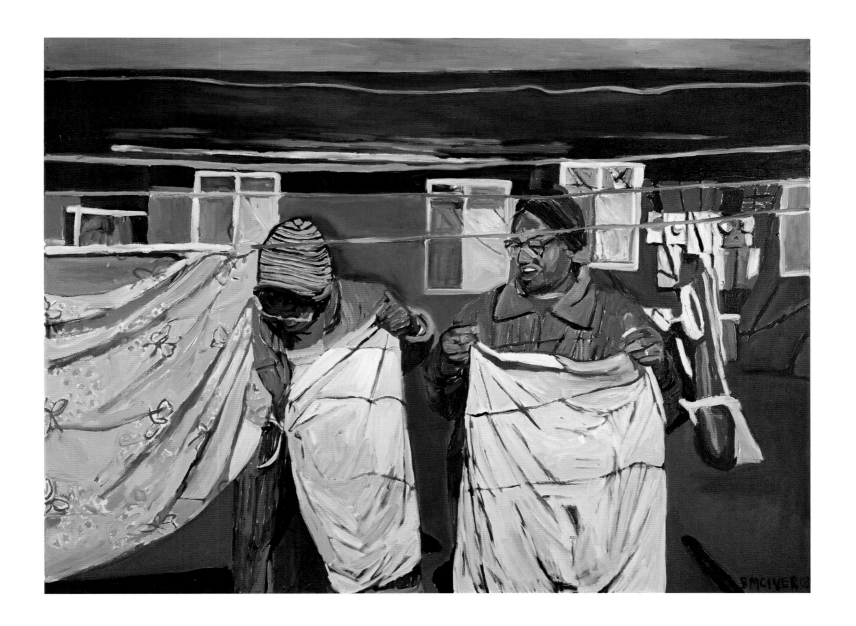

Plate 19 *Momma Holding Renee*, 2003. Oil on canvas; 40 × 30 in.

Plate 20 *Momma and Renee Hanging Out Clothes*, 2003. Oil on canvas; 36 × 48 in.

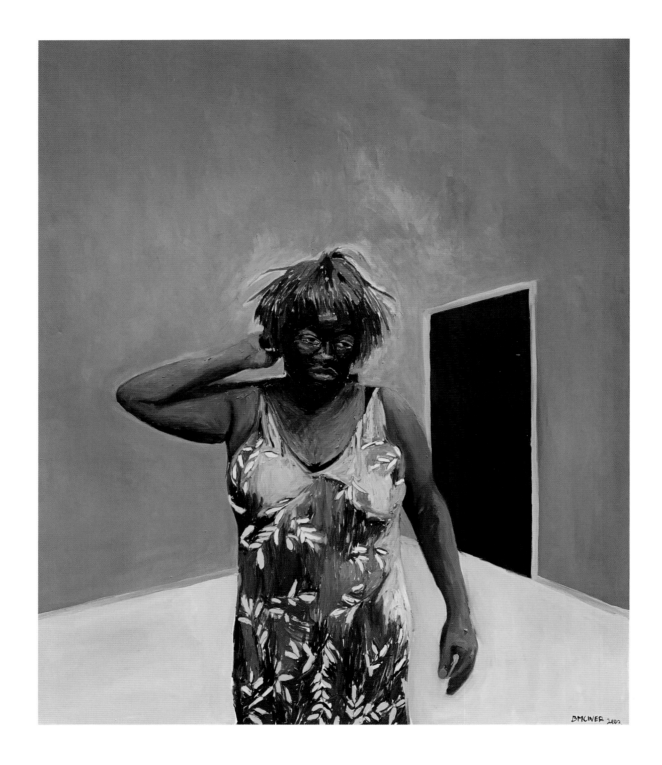

Plate 21 *Mourning Elizabeth #2*, 2003. Oil on canvas; 72 × 60 in.

Plate 22 *Momma*, 2003–04. Oil on canvas; 48 × 35¾ in.

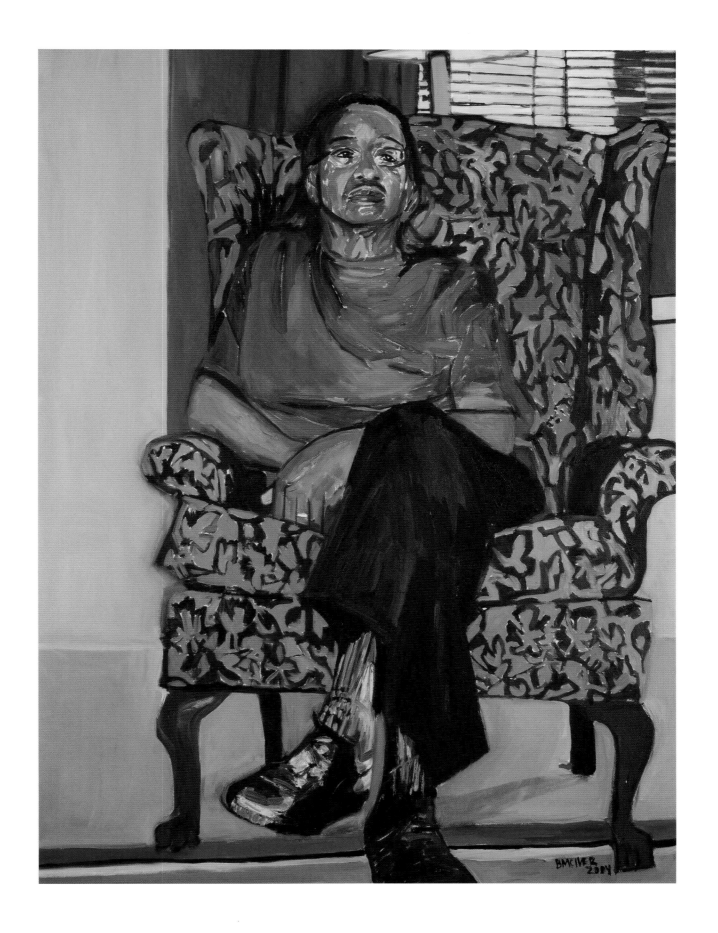

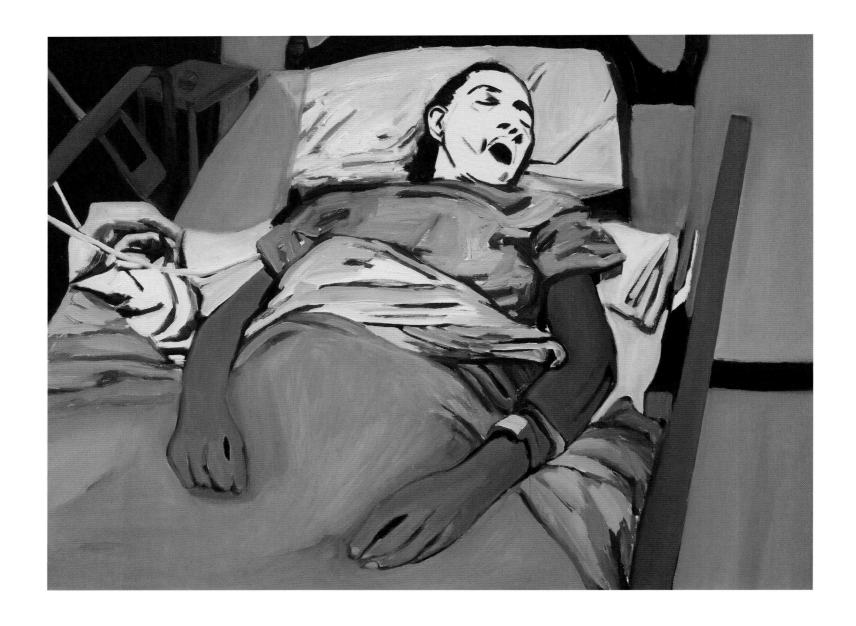

Plate 23 *Mom Died*, 2004. Oil on canvas; 36 × 48 in.

Plate 24 *Embrace*, 2005. Oil on canvas; 48 × 36 in.

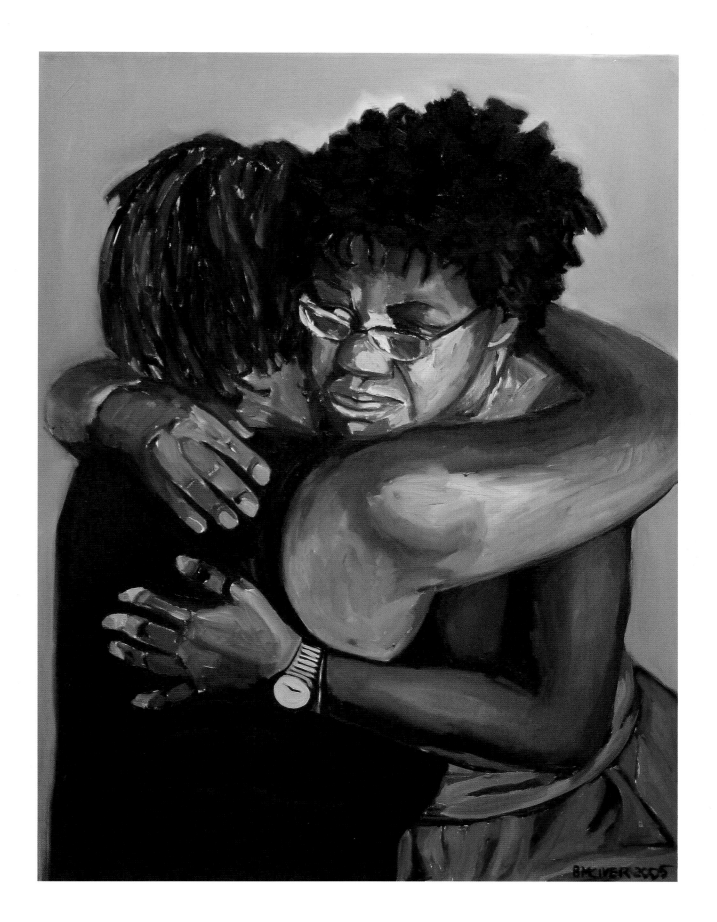

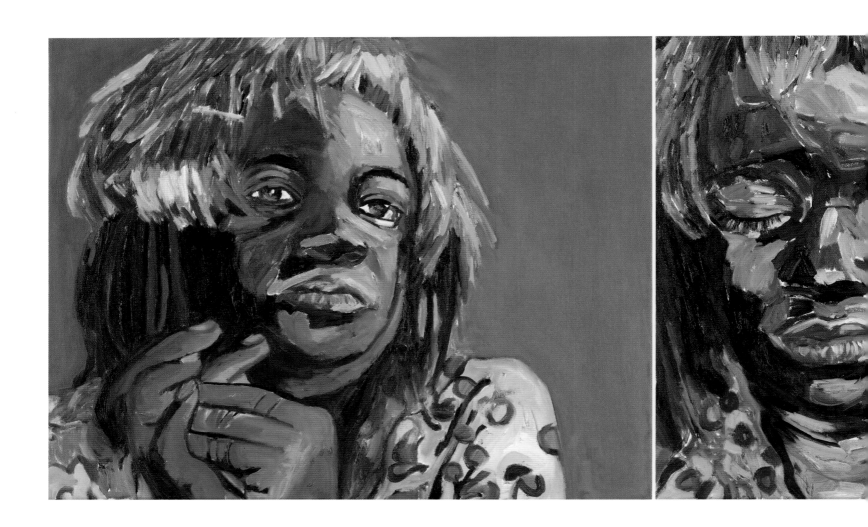

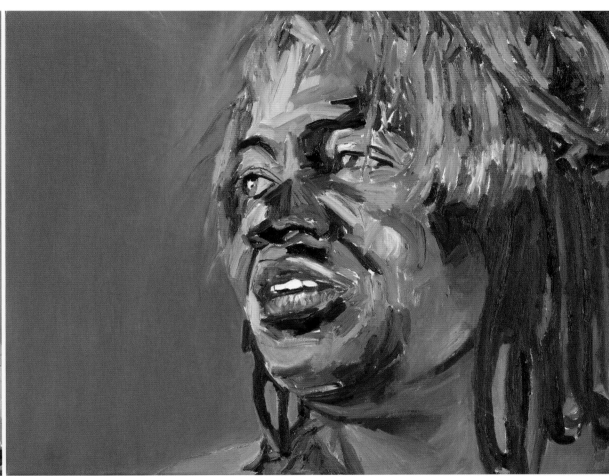

Plate 25 *Reminiscing*, 2005. Oil on canvas; 24 × 90 in. overall.

Plate 26 **Renee in Her Angel Costume**, 2006. Oil on canvas; 48 × 48 in.

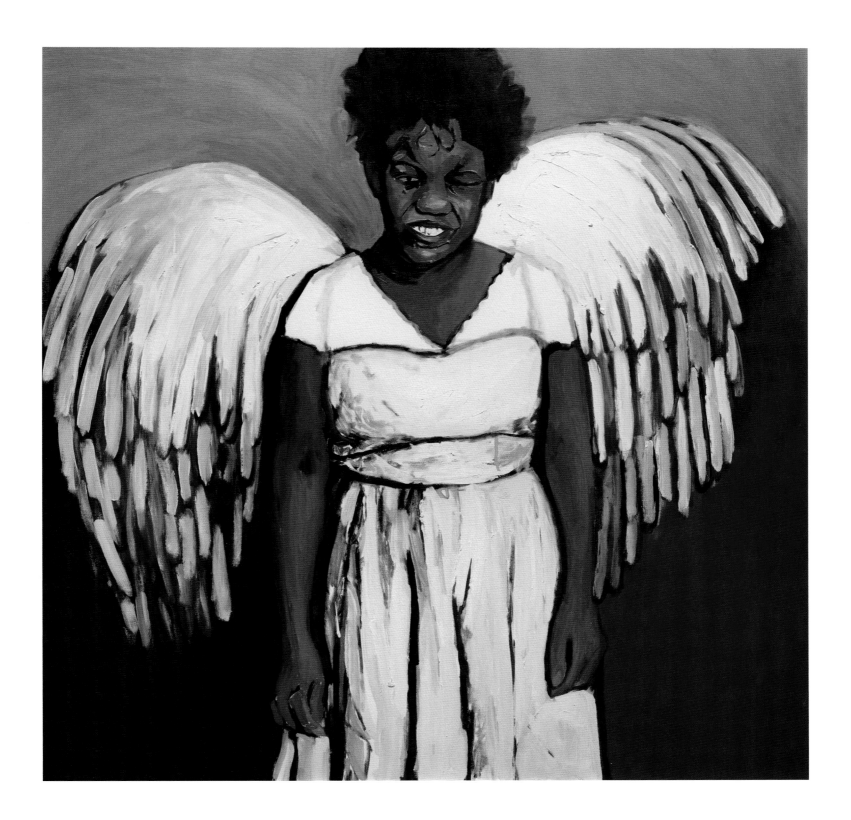

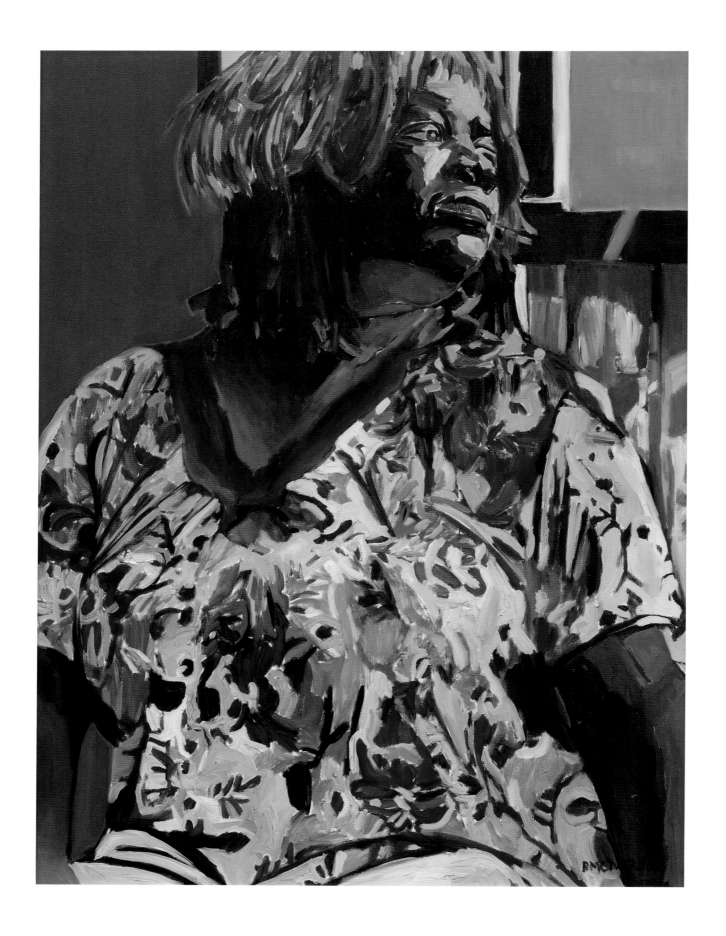

Plate 27 *Remembering Mom*, 2006. Oil on canvas; 60 × 60 in.

Dear God,
Today I got a propane taped to my door for over $800.⁰⁰ I almost died. How can propane in NC cost over $800.⁰⁰? I called the propane company assuming that it was a mistake. Or if not a mistake, it was cost of propane for the season. Wrong! According to the clerks estimation, it was propane for a two month period. I felt physically sick: I'm paying Boston prices for heat but living in NC. Please God help me to find a respite here. Help me to be happy about my your decision for me to move back to NC.

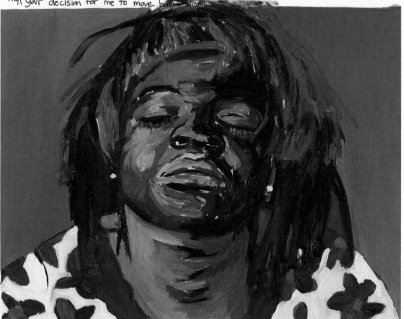

Dear God,
Tonight I am sad. My cousin Howard died of cancer. It was the same cancer that killed mom, prancreatic. Since I moved back to NC, I am keenly aware of death & the sickness that seem to plague my family. Sharon has diabetes and goes to dialysis three times a week. Cousin Will has heart problems and my cousin Wanda is battling breast cancer. I am sad for my sick relatives and all the sickness in this world. I am thankful that I am healthy. Tomorrow we will bury Howard.
1-15-2008

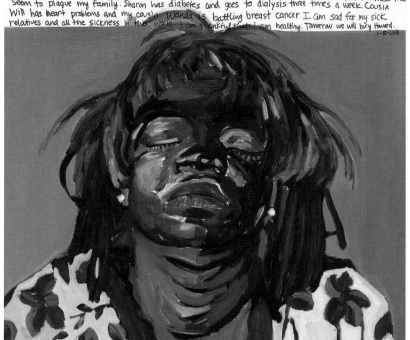

Dear God,
Today I purchased a pair of diamond earrings. Susan took me to a jewelry store in MA. I felt so grown up purchasing my first diamonds. I'll have to make a few payments before I actually get to wear them. It's 1 carat between the two earrings. I'm so excited and what a thrill to share it with my friend Susan who is Queen of jewelry. I hope to pay them off by Oct. Just in time for the fall. Hurray!! What a joy.

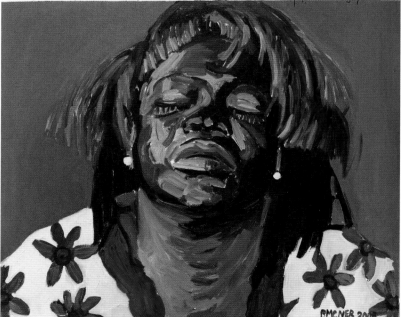

Dear God—
Today I went to get my NC drivers license. This was my fourth visit to the DMV. I was not allowed to take the test because I did not have a social security card. On a previous visit I was told that my tax returns would be proof of my social security number. Apparently, the rule changed, effective today Feb 4th everyone has to have a social security card. I left the DMV mad. I headed over to the social security office to apply for a social security replacement card. The office of course, was full and the wait was estimated at over an hour. I left, mad as hell. On the social security application they ask for both mother & father social security numbers. Where in the hell am I going to get that information. Looks like I'll never get a NC driver's license.

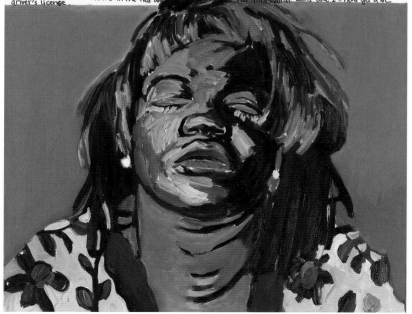

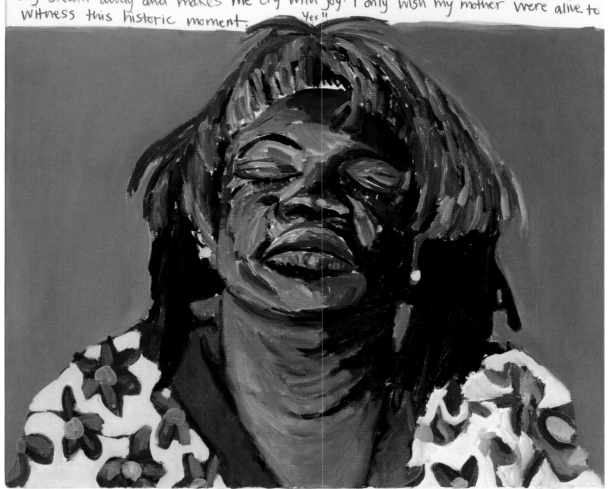

Plate 28 *Propane*, from the *Dear God* series, 2007–10. Oil on canvas; 30 × 30 in.

Plate 29 *Cousin's Cancer*, from the *Dear God* series, 2007–10. Oil on canvas; 30 × 30 in.

Plate 30 *Diamonds*, from the *Dear God* series, 2007–10. Oil on canvas; 30 × 30 in.

Plate 31 *Driver's License*, from the *Dear God* series, 2007–10. Oil on canvas; 30 × 30 in.

Plate 32 *Barack Obama*, from the *Dear God* series, 2007–10. Oil on canvas; 30 × 30 in.

Plate 33 *Vegas Vacation*, from the **Dear God** series, 2007–10. Oil on canvas; 30 × 30 in.

Plate 34 *Kennedy Died*, from the **Dear God** series, 2007–10. Oil on canvas; 30 × 30 in.

Plate 35 *Prison–Artist*, from the **Dear God** series, 2007–10. Oil on canvas; 30 × 30 in.

Plate 36 *Depression and Shoes*, from the **Dear God** series, 2007–10. Oil on canvas; 30 × 30 in.

Dear God,
Today Renee & I returned from a week long vacation in Las Vegas. We had a really fun time. We both gambled but Renee was the only one to win. She played the Wheel of Fortune slot machine. Each time she played, she prayed for cherries! It was a blast to watch her excitement. A few times she asked God to forgive her for gambling. I told her that God was happy that gambling made her so happy.

Dear God,
Today Senator Ted Kennedy died. He had been battling brain cancer for several months. I felt sad when I heard the news; sad that the world had lost yet another Kennedy. Intuitively, I felt like he was a good man. He had a lot and he gave a lot. Ted Kennedy cared about "the little people" and he wanted equality for everyone. He wanted health insurance for all. What a great guy. He will be missed on this earth.
— Sept. 2009 BMcIVER

Dear God,
Today I received a letter from a prisoner. The prisoner is an artist and learned about my work through a newspaper article in the Greensboro News & Record. The prisoner says a fellow inmate read the article to him. He says that he can not read or write. He also enclosed a portrait he had painted of me from a photo reproduced in the paper. He's quite talented—very talented. I am very sad that he cannot read or write. I am not sure how to respond to his letter or if I should. What should I do?

Dear God,
I must be depressed, as I found myself ordering a pair of shoes from Zappo.com. I've noticed a pattern with depression and logging on to Zappo. The shoes are quite cute. They are slip-ons and lime green. Perfect for a summer in NC. It's hot today. It was 90° at 12:00 noon. We didn't go outside. We are bracing ourselves for our first summer at home in NC.

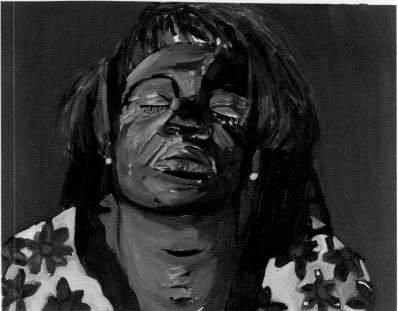

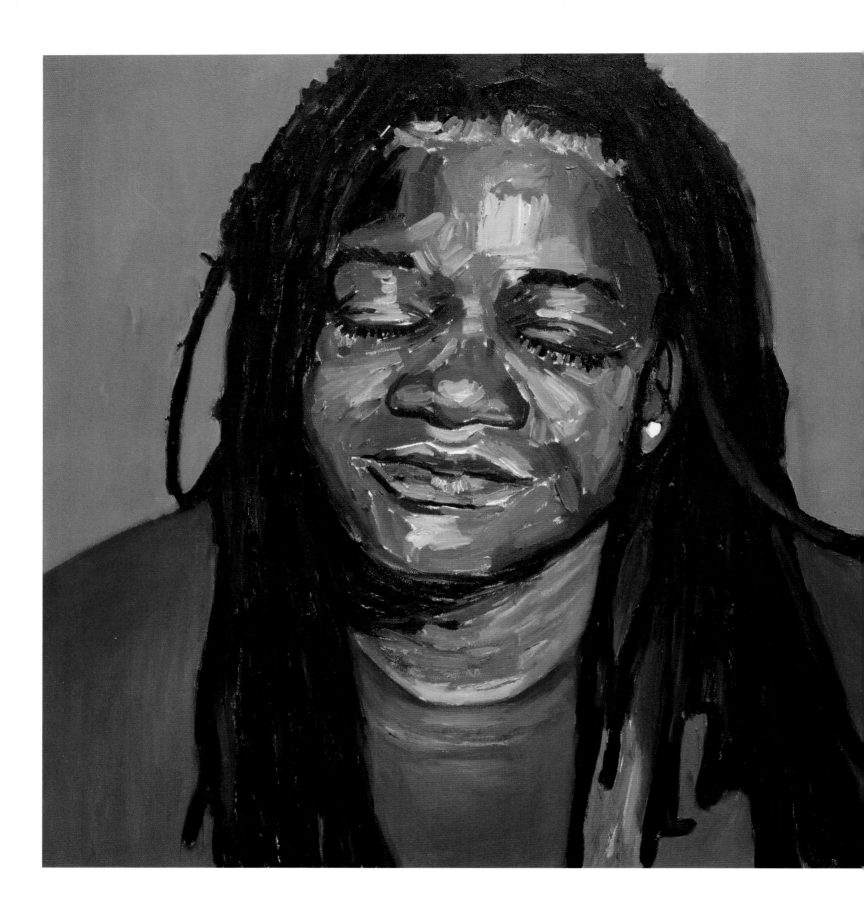

Plate 37 **Finding Peace #1**, 2009. Oil on canvas; 30 × 40 in.

Plate 38 *Depression*, 2010. Oil on canvas; five panels, each 30 × 40 in.

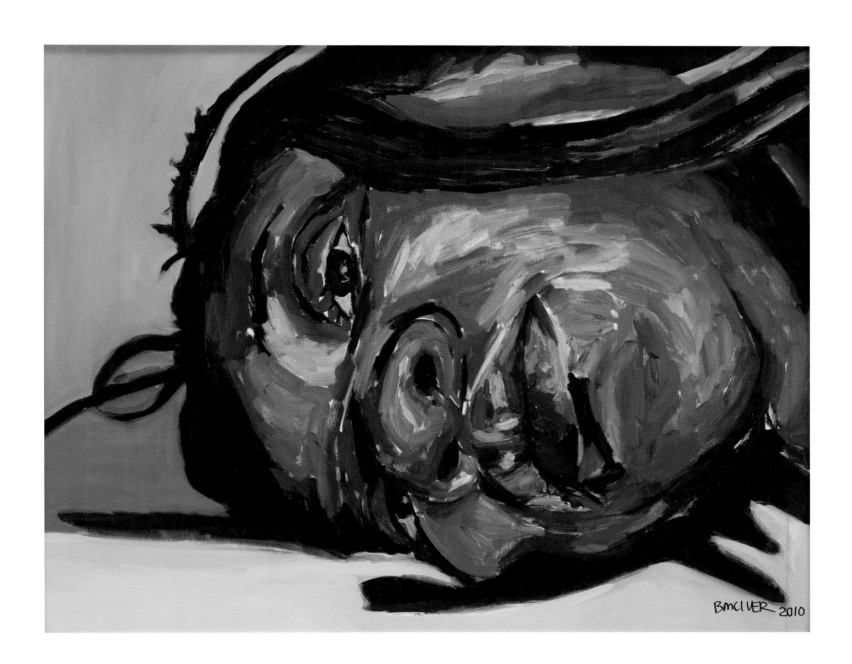

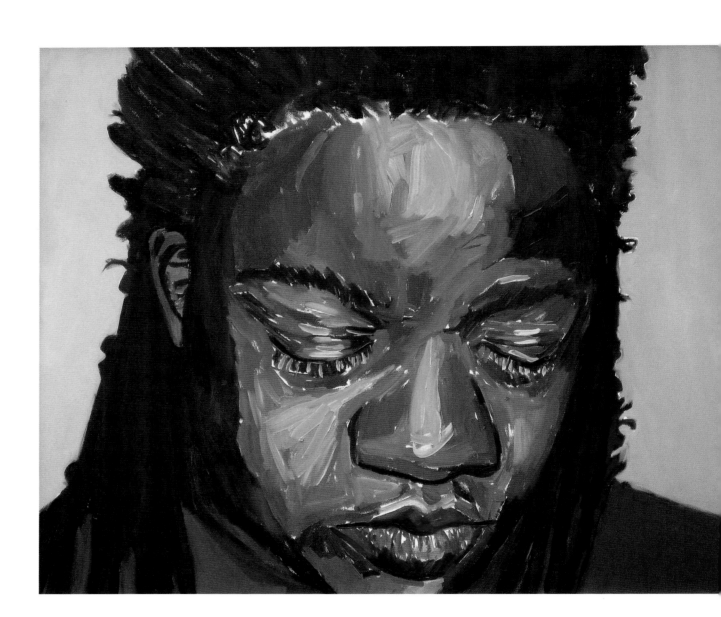

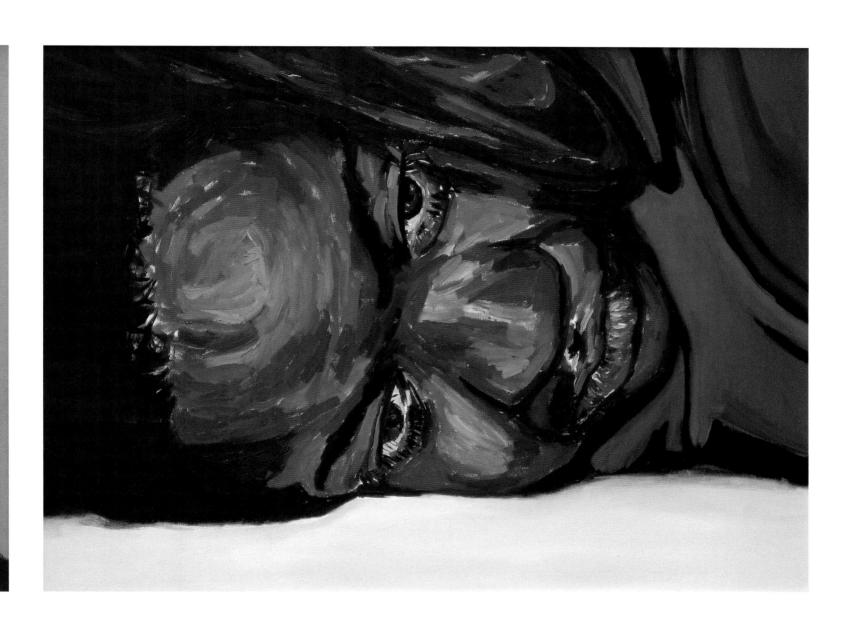

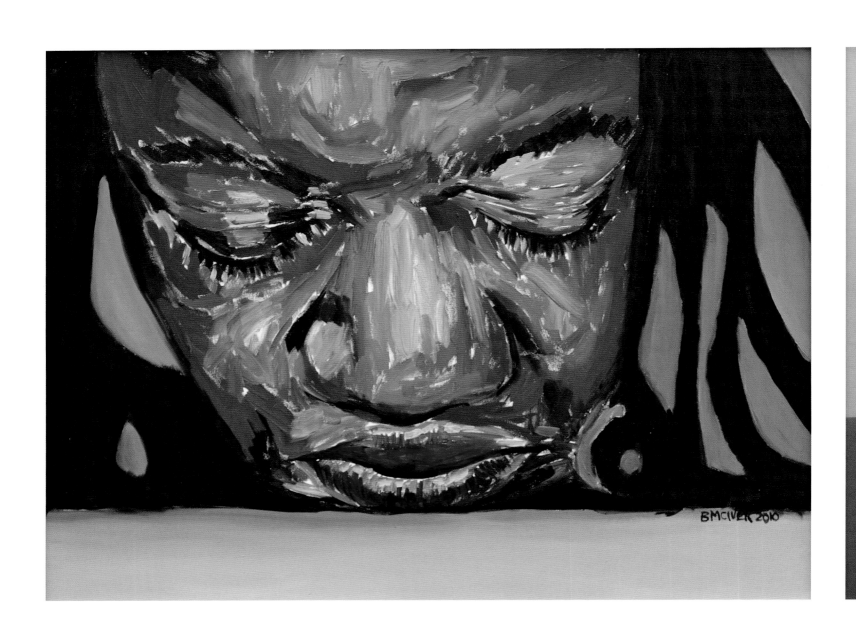

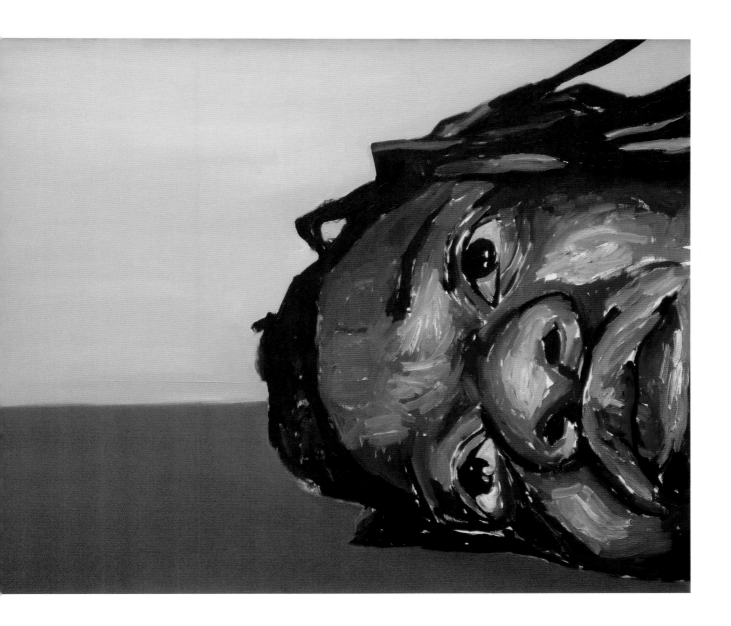

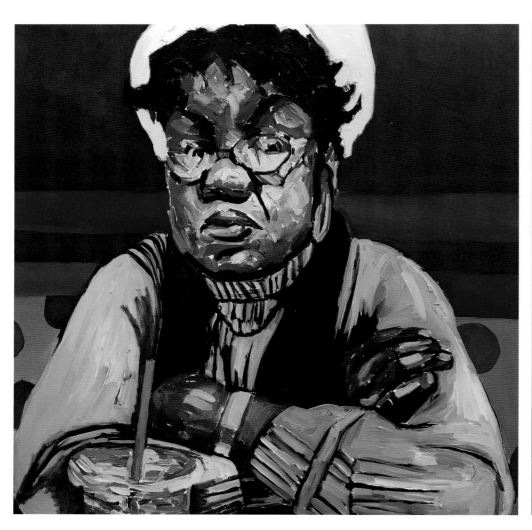

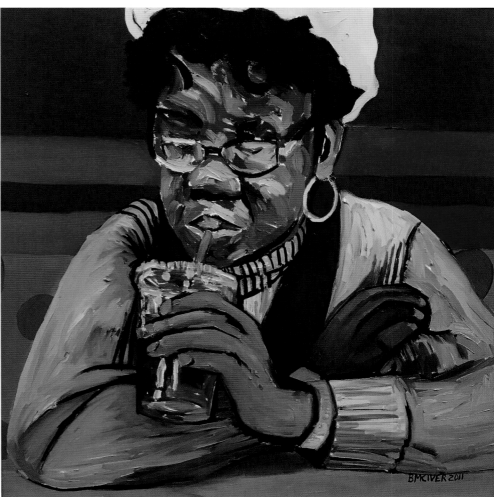

Plate 39 *Renee Drinking Starbucks*, 2011. Oil on canvas; 30 × 108 in. overall.

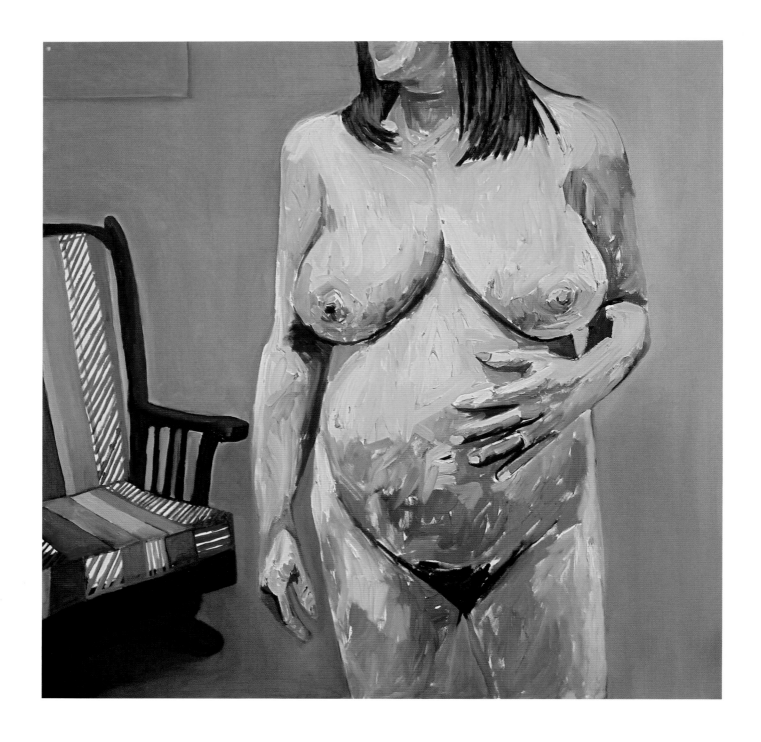

Plate 40 *Annah Pregnant*, 2013. Oil on canvas; 48 × 48 in.

Plate 41 *Bill T. Jones*, 2013. Oil on canvas; 48 × 48 in.

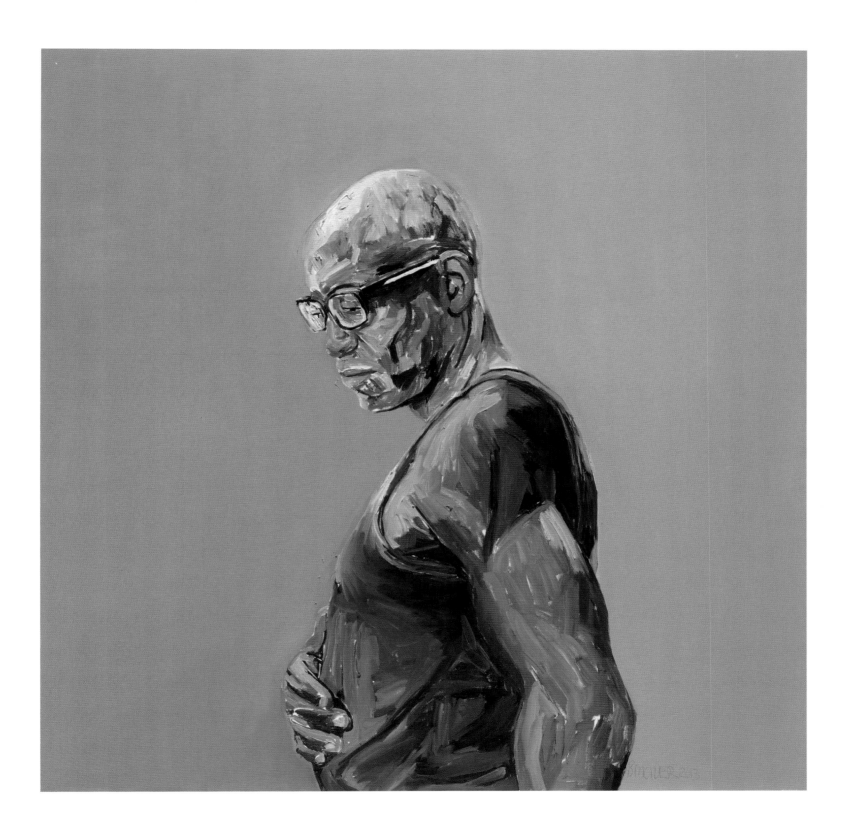

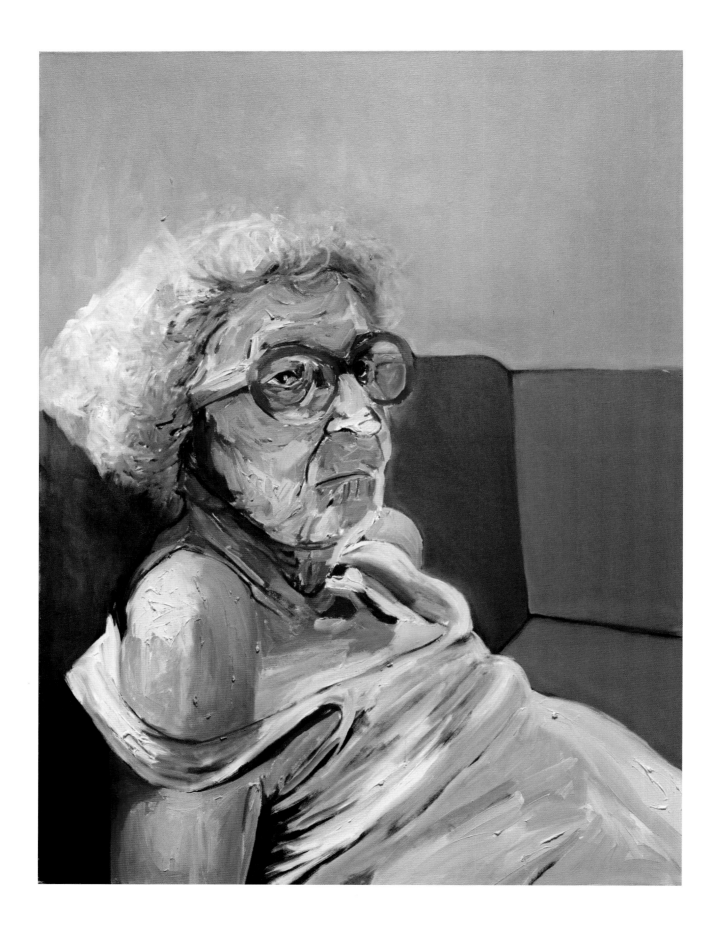

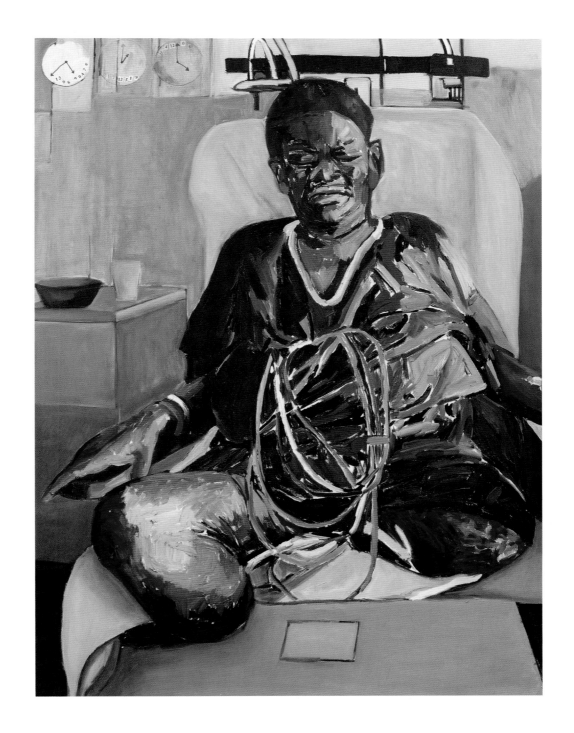

Plate 42 *Dorothy*, 2013. Oil on canvas; 40 × 30 in.

Plate 43 *Double Amputee*, 2013. Oil on canvas; 48 × 36 in.

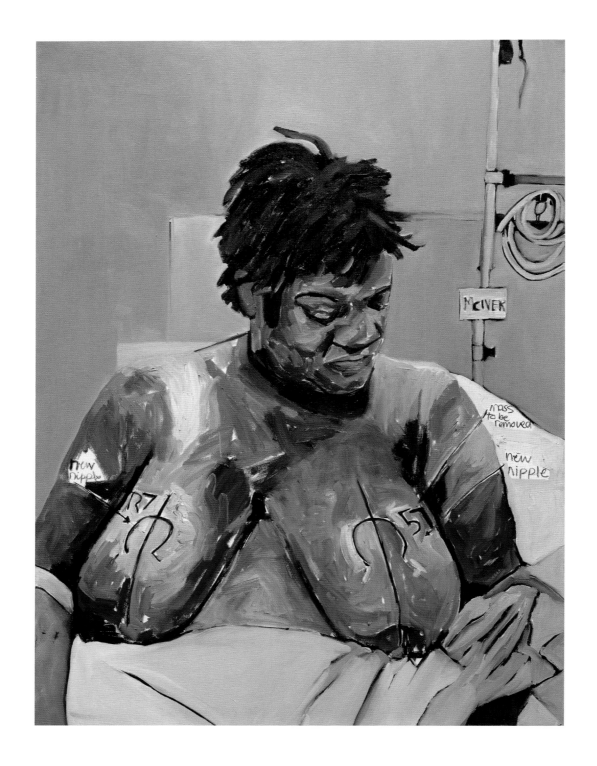

Plate 44 *Pre-Breast Surgery #2*, 2013. Oil on canvas; 48 × 36 in.

Plate 45 *Kim Coming Out of Anesthesia*, 2015. Oil on canvas; 40 × 30 in.

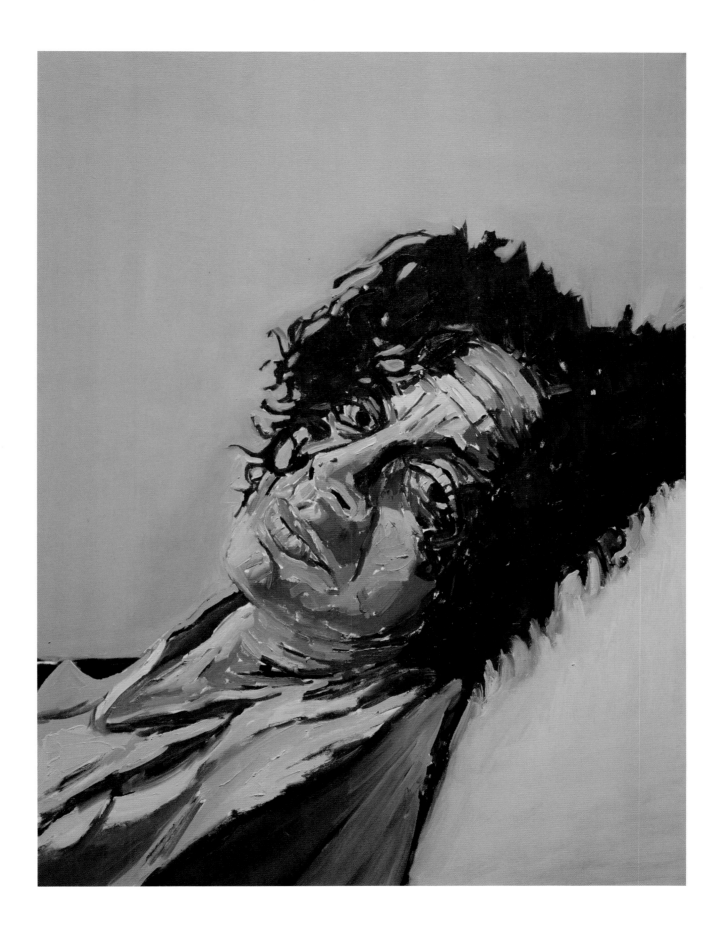

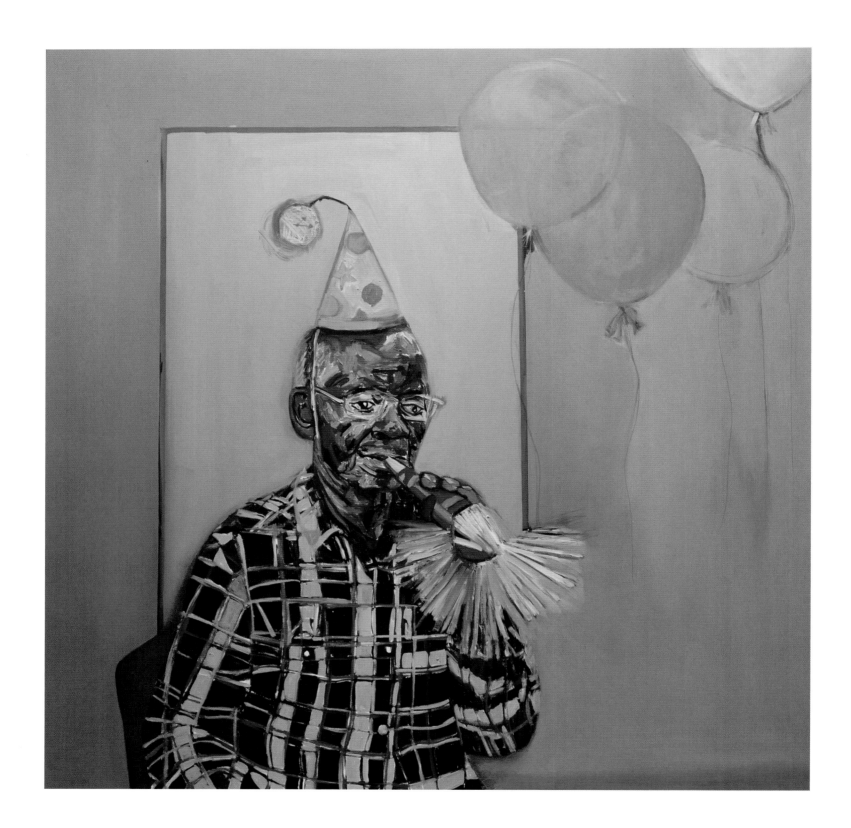

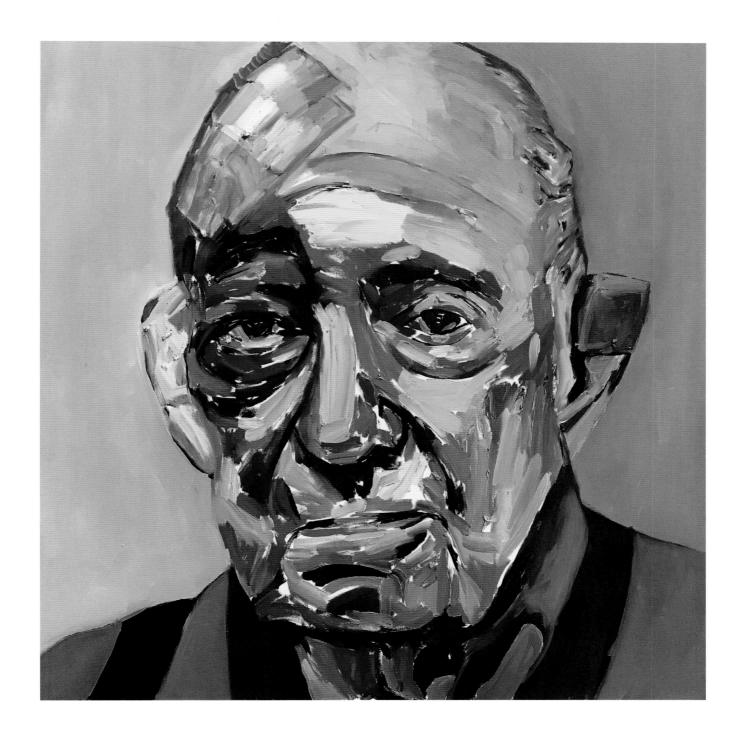

Plate 46 *Daddy's Birthday*, 2015. Oil on canvas; 60 × 60 in.

Plate 47 *Philip Pearlstein*, 2015. Oil on canvas; 30 × 30 in.

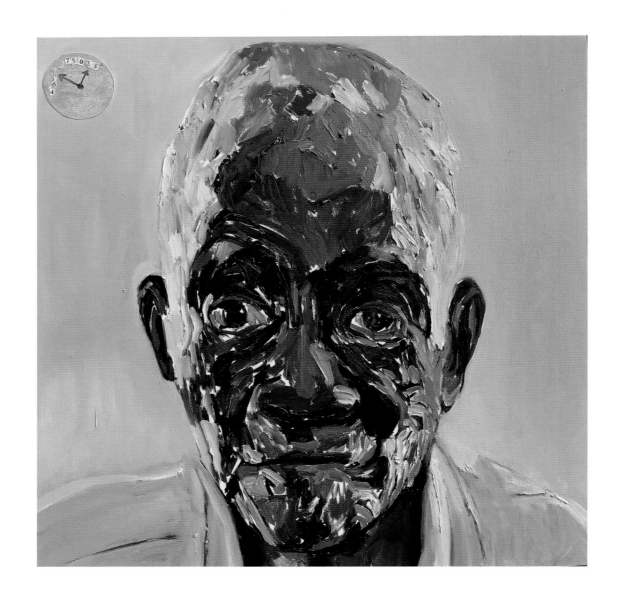

Plate 48 *Cardrew 2*, 2016. Oil on canvas; 30 × 30 in.

Plate 49 *Loving Grace*, 2016. Oil on canvas; 30 × 30 in.

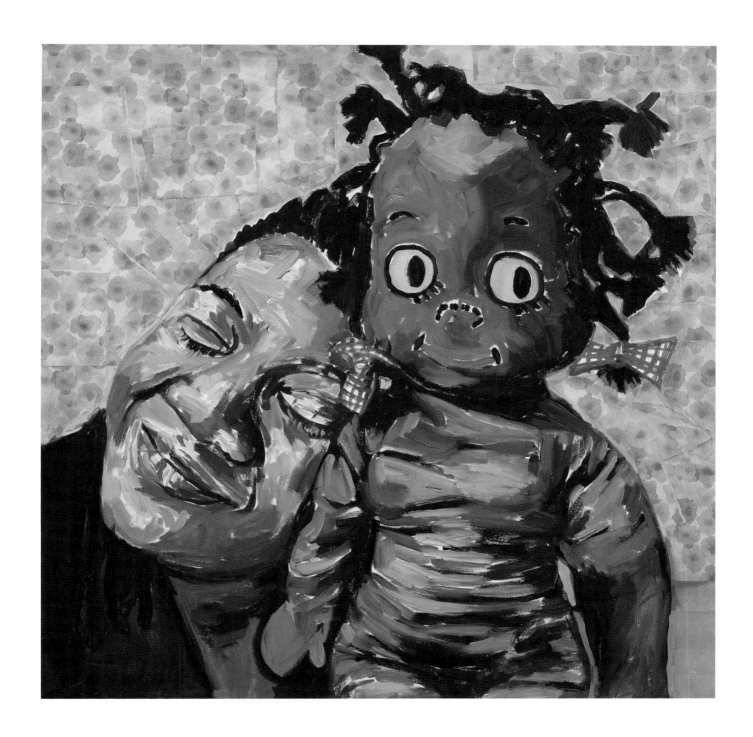

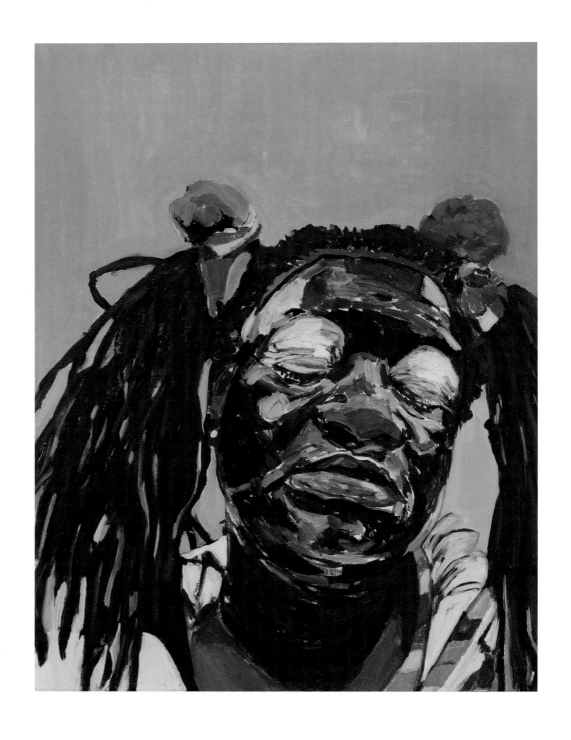

Plate 50 *Clown Portrait*, 2018. Oil on canvas; 45 × 34 in.

Plate 51 *Brown Girl Memory*, 2018 (collaboration with Gaetona Casseli). Oil and mixed media on canvas; 77 × 38 in.

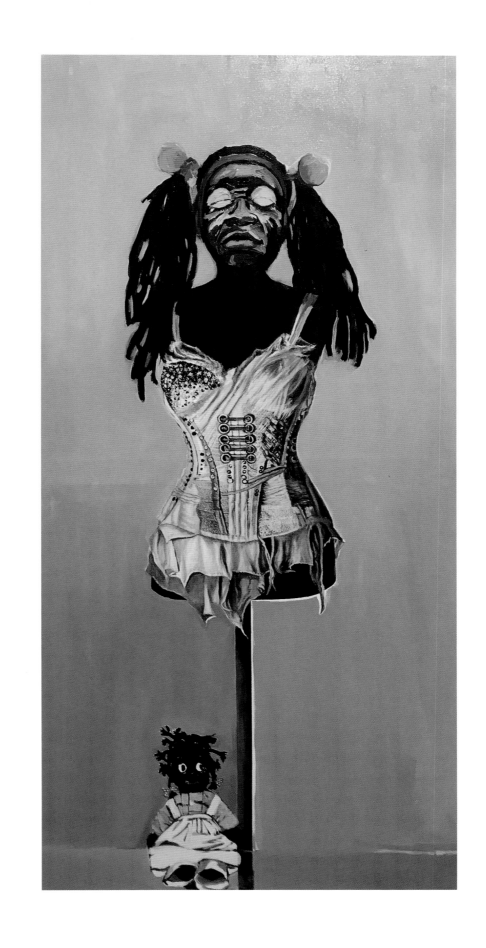

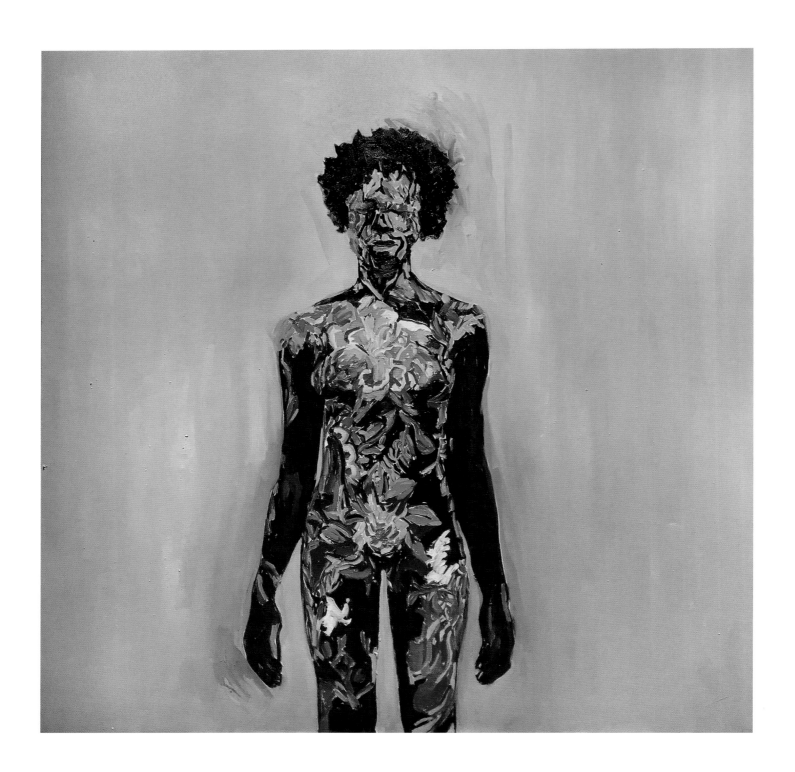

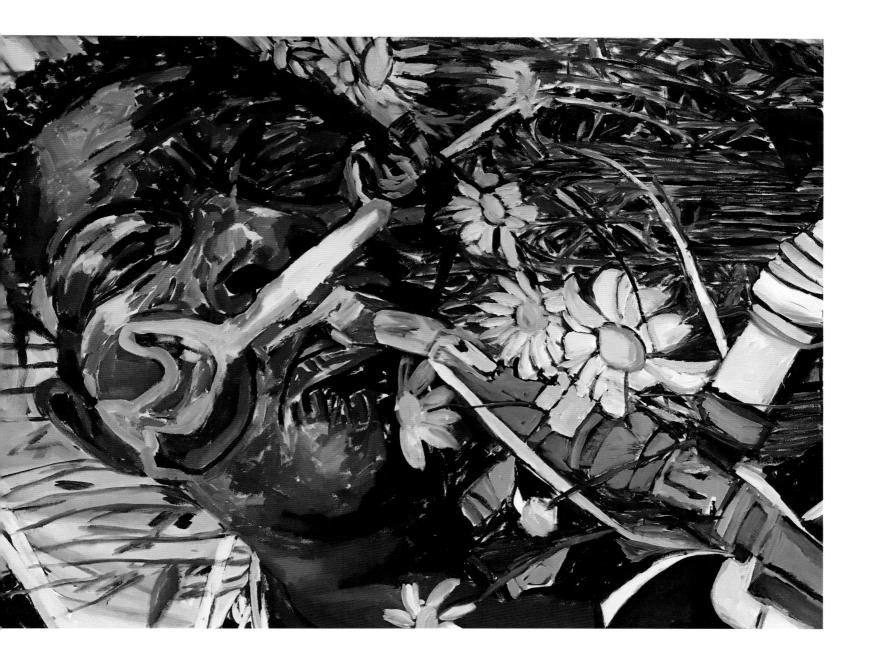

Plate 52 *Black Girl Beauty*, 2018. Oil on canvas; 48 × 48 in.

Plate 53 *Sharon Pushing Up Daisies #1*, 2018. Oil on canvas; 29 × 45 in.

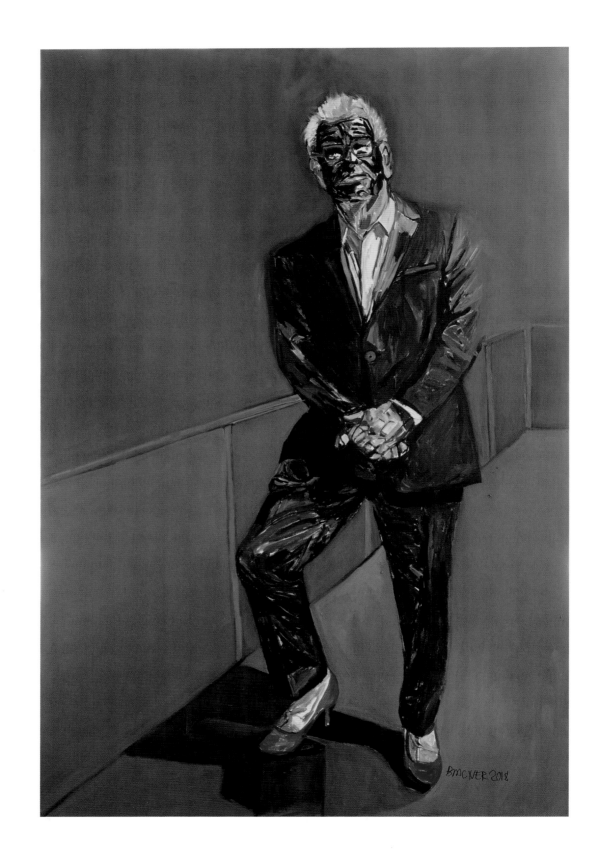

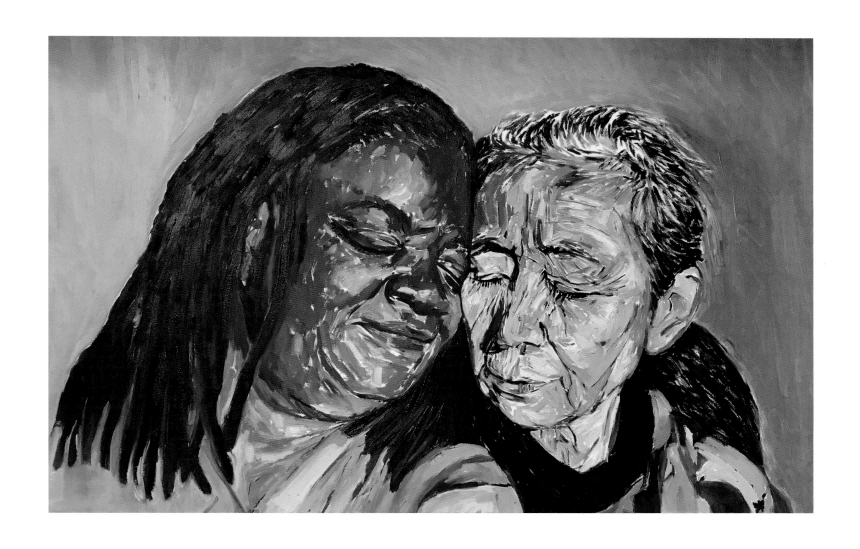

Plate 54 *Larry*, 2018. Oil on canvas; 72 × 60 in.

Plate 55 *Eiko Collaborative Painting 1*, 2019. Oil on canvas; 48 × 36 in.

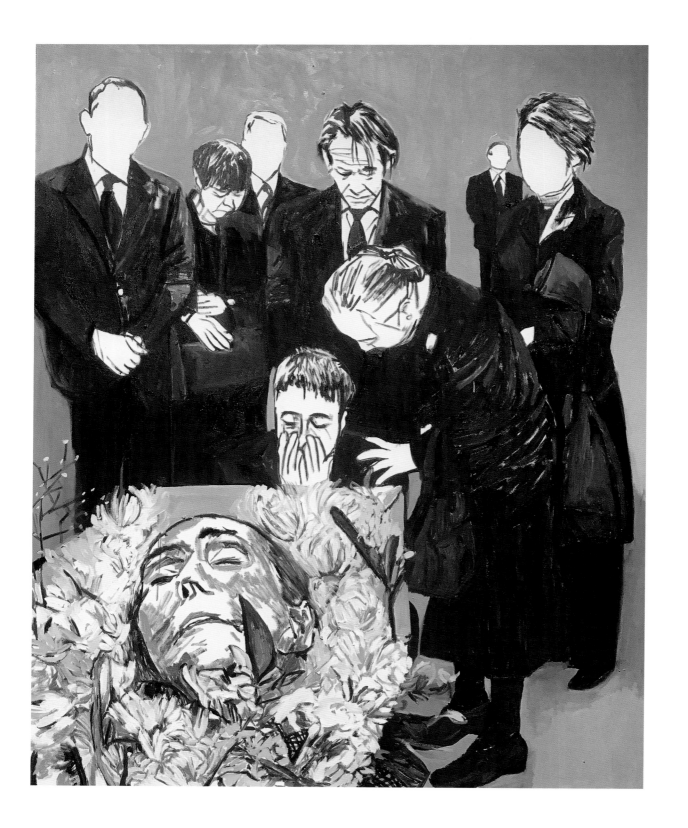

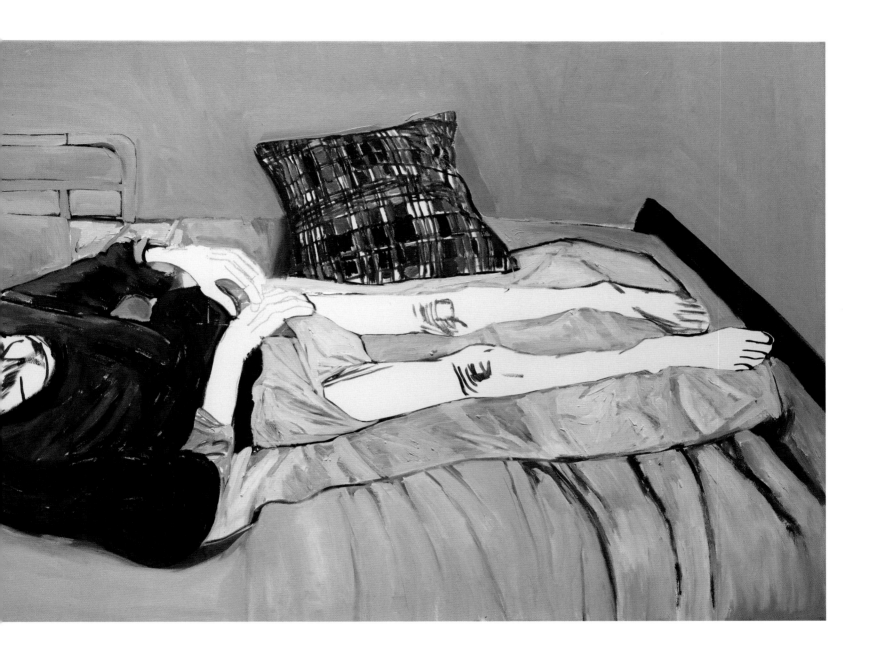

Plate 56 *Eiko Collaborative Painting 2*, 2019. Oil on canvas; 36 × 48 in.

Plate 57 *Eiko Collaborative Painting 3*, 2019. Oil on canvas; 48 × 36 in.

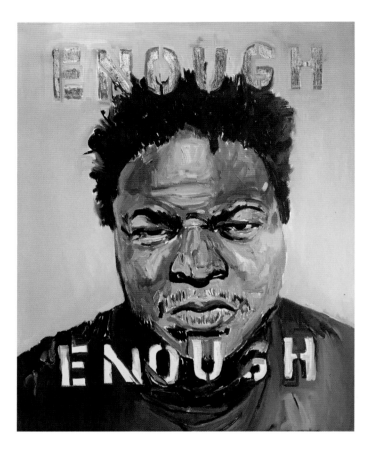
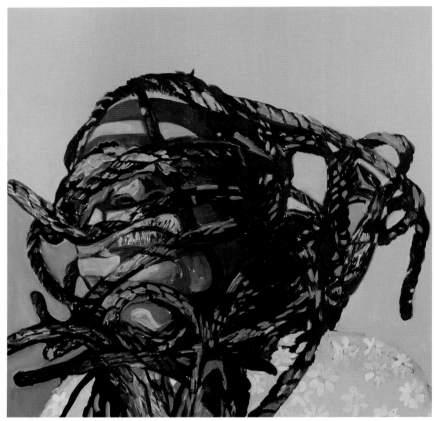

Plate 58 **Enough**, 2020. Oil on canvas; 30 × 24 in.

Plate 59 **Defiant**, 2020. Oil on canvas; 48 × 48 in.

Plate 60 **Praying Hands**, 2020. Oil on canvas; 40 × 30 in.

106

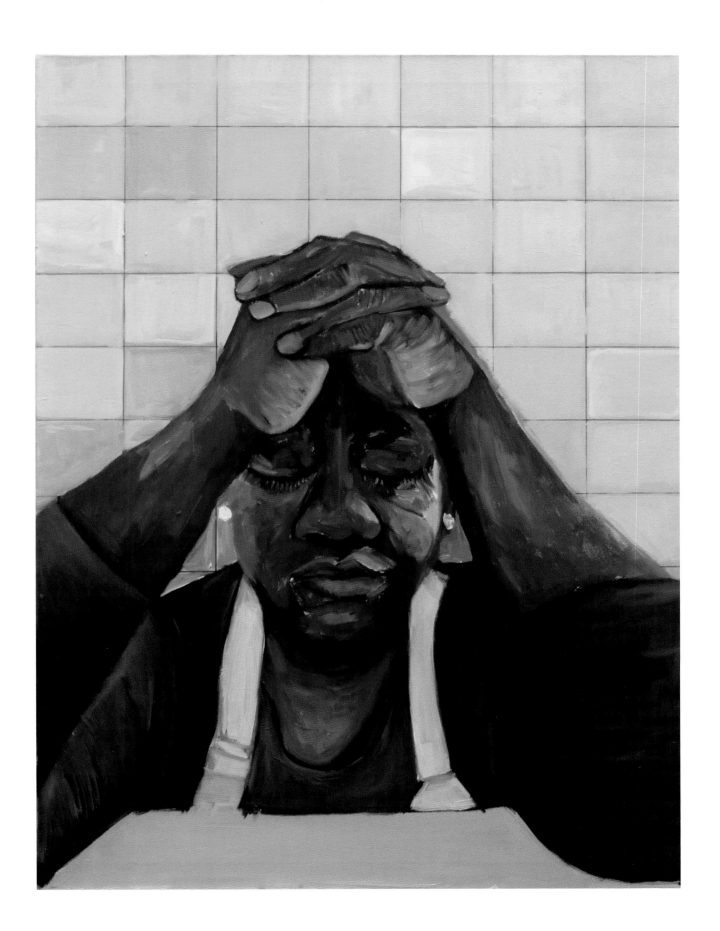

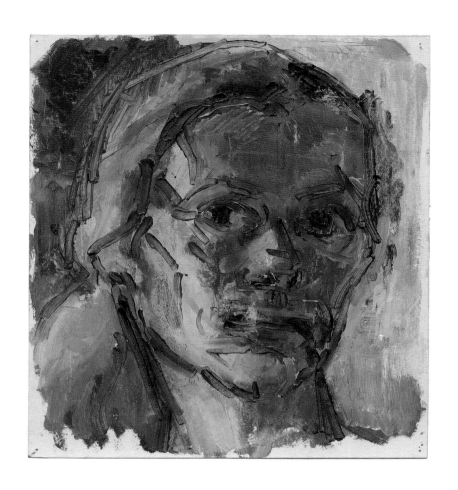

Plate 61 Elizabeth Lentz, *Self-Portrait*, 1982. Oil on paper; 21 × 18 in.

Plate 62 Elizabeth Lentz, *Untitled (Still Life)*, 1984. Oil on paper; 22 × 28 in.

Plate 63 Richard Mayhew, *Untitled Landscape*, c. 2006. Oil on canvas; 31 × 37 in.

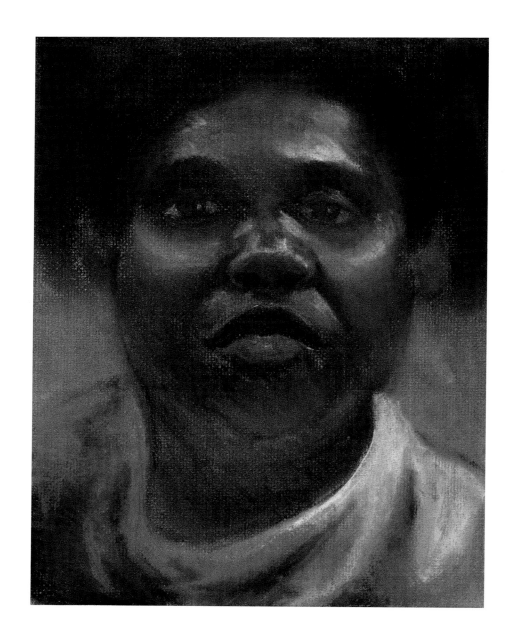

Plate 64 Richard Mayhew, **Untitled Portrait of a Black Woman**, c. 1990. Pastel on paper; 18 × 15 in.

Plate 65 Faith Ringgold, **Tar Beach #2**, 1990–92. Silkscreen on silk; 66 × 65 in.

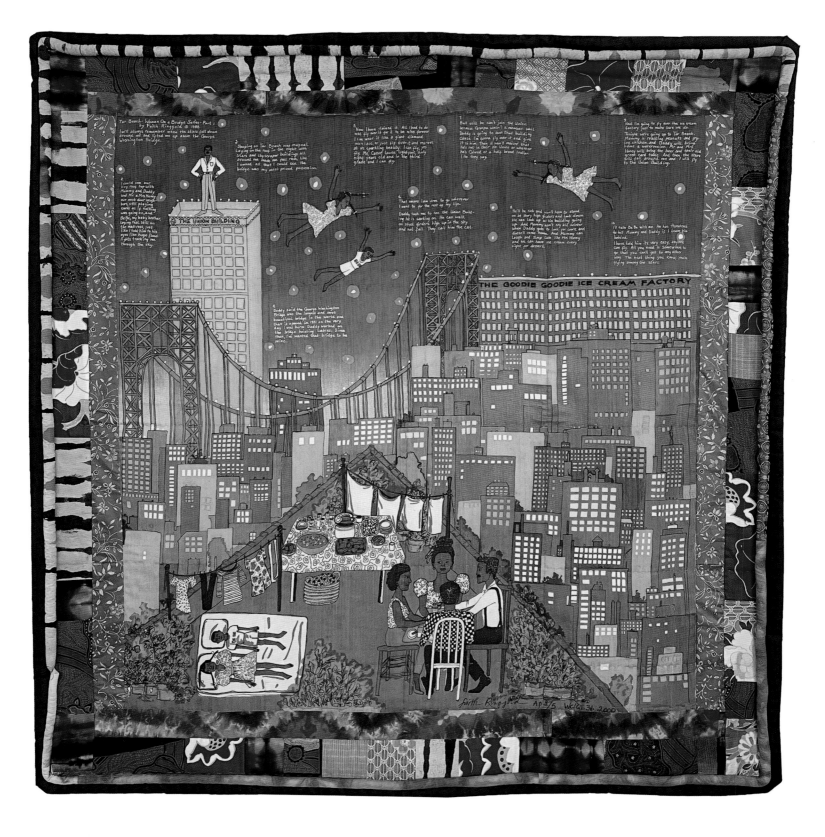

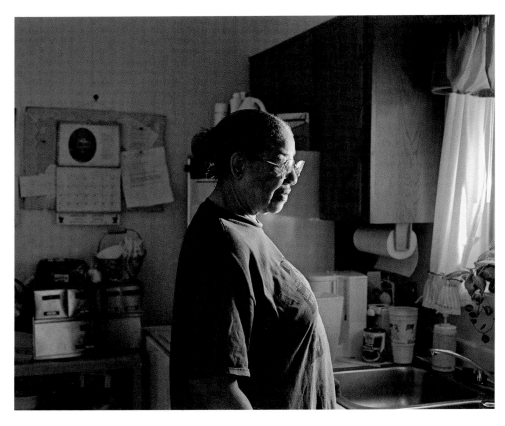

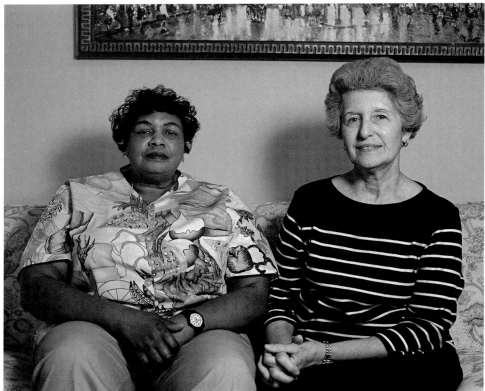

Plate 66 Ernie Button, *Ethel at the Sink*, 2002. Gelatin silver print; 15 × 18 in.

Plate 67 Ernie Button, *Lillie and Ellen*, 2002. Gelatin silver print; 15 × 18 in.

Plate 68 Ernie Button, **Support**, 2002. Gelatin silver
print; 15 × 18 in.

Plate 69 Ernie Button, **Mother Horton**, 2002. Gelatin
silver print; 15 × 18 in..

Plate 70 melissa m button, *extensions beyond this point*, 2016. Mixed-media collage; 15 × 15 in.

Plate 71 melissa m button, *portals of perception*, 2016. Mixed-media collage; 15 × 15 in.

Plate 72 Claudio Dicochea, *De Teniente Comandante y el caso de la ceacia liberadora, la Barbaridad*, 2017. Acrylic, graphite, charcoal, and transfer on wood; 48 × 36 in.

Plate 73 Michael Dixon, *Make America Great Again*, 2017. Oil on canvas; 48 × 48 in.

Plate 74 Carrie Hott, *Motion Zone 1*, 2019. Digital Print; 14 × 17 in.
Plate 75 Carrie Hott, *Motion Zone 2*, 2019. Digital Print; 14 × 17 in.

Plate 76 Mary Porterfield, *In Silence*, 2017. Oil on layered glassine; 30 × 60 in.

Plate 77 Chris Santa Maria, *No. 5*, 2014. Paper collage and acrylic on MDF; 58 × 60 in.

Plate 78 Damian Stamer, *New Sharon Church Rd 49*, 2018. Oil on panel; 72 × 48 in.

Plate 79 Lamar Whidbee, *Prodigal Son*, 2017. Mixed media (door frame, oil paint, cubic zirconia, exit sign); 83 × 36 in.

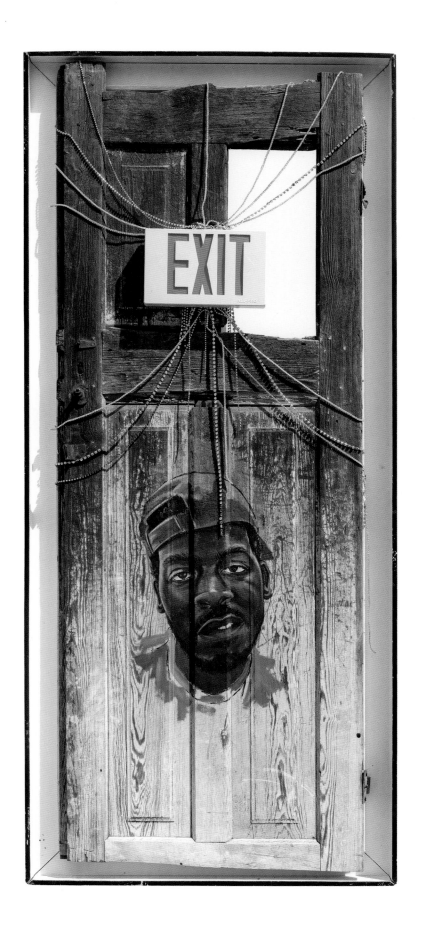

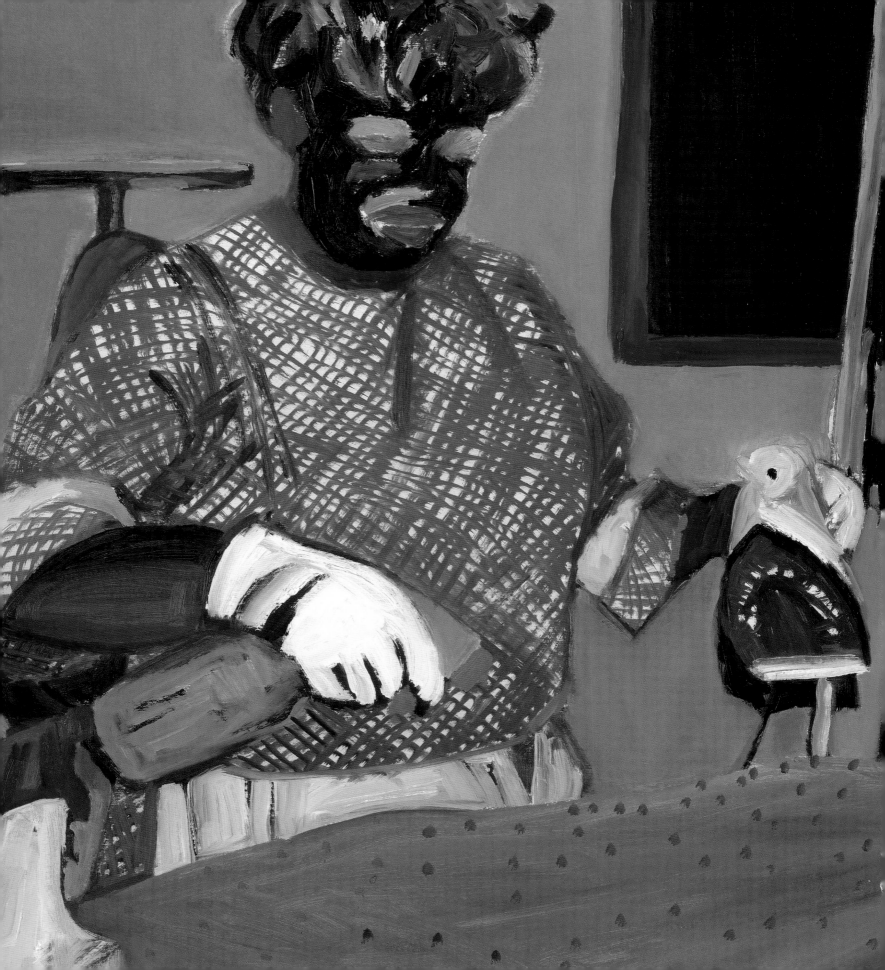

EXHIBITION CHECKLIST

Unless otherwise noted, all works are courtesy of the artist.

BEVERLY McIVER

1
Can You Hear My Silent Scream, 1994
Oil on canvas; 38½ × 40½ in.
Courtesy of Betty Cuningham Gallery, New York

2
My Pretty Red Outfit, 1994
Oil on canvas; 22 × 28 in.
Collection of Jane Shuping Tyndall, Denver, CO

3
York Garrett, 1994
Oil on canvas; 33½ × 23 in.
Courtesy of Craven Allen Gallery, Durham, NC

4
Black Self, 1996
Oil on canvas, collage; 17¼ × 17¼ in.
Collection of Godfrey Herndon, Durham, NC

5
White Girl, 1996
Oil on paper with ink text; 39 × 30¼ in.
Collection of Godfrey Herndon, Durham, NC

6
White Face, 1996
Oil on paper; 22 × 10 in.
Courtesy of Craven Allen Gallery, Durham, NC

7
Good Times #3, 1997
Oil on canvas; 30 × 20 in.
Collection of Michael Dixon, Albion, MI

8
Life Is Sweet, 1998
Oil on canvas; 48 × 36 in.
Collection of the Scottsdale Museum of Contemporary Art; purchased with funds from the New Directions Fund

9
Loving in Black and White #3, 1998
Oil on canvas; 40 × 34 in.
Courtesy of Craven Allen Gallery, Durham, NC

10
Loving in Black and White #5, 1999
Oil on canvas; 41 × 35 in.
Courtesy of Craven Allen Gallery, Durham, NC

11
Invisible Me, 1999
Oil on canvas; 35½ × 35½ in.
Collection of Douglas Walla, New York

12
Molly and Her Mammy, from the *Mammy How I Love You* series, 1999
Oil on canvas; 30 × 40 in.
Courtesy of Bernice Steinbaum Gallery, Miami

13
Jumping for Joy, 1999
Oil on canvas; 60 × 49 in.
Collection of the Arizona State University Art Museum, Tempe; gift of Stanley and Muriel Weithorn Resident Trust in honor of Marilyn A. Zeitlin and Heather Sealy Lineberry

14
Amazing Grace, 2000
Oil on canvas; 48 × 36 in.
Collection of the Weatherspoon Art Museum, University of North Carolina, Greensboro. Museum purchase with funds from the Weatherspoon Art Museum Acquisition Endowment, 2002

15
Five Days of Feeling, 2002
Oil on canvas; 49 × 180 in. overall
Collection of Craig Pearson, Scottsdale

16
A Woman's Work, 2002
Oil on paper; Sheet: 28 × 42 in.
Baltimore Museum of Art: Purchased as the gift of the
Joshua Johnson Council, BMA 2003.32

17
Dora's Dance #3, 2002
Oil on canvas; 60 × 48 in.
Collection of The Mint Museum, Charlotte, NC; purchased with funds provided by Jay Everette, Ronald Carter, Cheryl Palmer and Frank Tucker, Andy Dews and Tom Warshauer, Dee Dixon, Patty and Alex Funderburg, Michael J. Teaford and R. K. Benites, Sharon and Rob Harrington, June and Ken Lambla, Mike Davis, Judy and Patrick Diamond, Anonymous Donor in honor of Amber Smith, Anonymous Donor

18
Dancing for My Man, 2003
Oil on canvas; 48 × 96 in.
Collection of Noel Kirnon and Michael Paley, New York

19
Momma Holding Renee, 2003
Oil on canvas; 40 × 30 in.
Courtesy of Craven Allen Gallery, Durham, NC

20
Momma and Renee Hanging Out Clothes, 2003
Oil on canvas; 36 × 48 in.
Collection of melissa m and Ernie Button, Phoenix

21
Mourning Elizabeth #2, 2003
Oil on canvas; 72 × 60 in.
Courtesy of Craven Allen Gallery, Durham, NC

22
Momma, 2003–04
Oil on canvas; 48 × 35¾ in.
Courtesy of Craven Allen Gallery, Durham, NC

23
Mom Died, 2004
Oil on canvas; 36 × 48 in.
Courtesy of Craven Allen Gallery, Durham, NC

24
Embrace, 2005
Oil on canvas; 48 × 36 in.
Collection of Judi Roaman and Carla Chammas, New York

25
Reminiscing, 2005
Oil on canvas; 24 × 90 in. overall
Collection of the North Carolina Art Museum, Raleigh; purchased with funds from the William R. Roberson Jr. and Frances M. Roberson Endowed Fund for North Carolina Art

26
Renee in Her Angel Costume, 2006
Oil on canvas; 48 × 48 in.
Courtesy of Craven Allen Gallery, Durham, NC

27
Remembering Mom, 2006
Oil on canvas; 60 × 60 in.
Collection of Nick Cave, Chicago

28
Propane, from the **Dear God** series, 2007–10
Oil on canvas; 30 × 30 in.
Collection of Laura Lee Brown and Steve Wilson, 21c Museum Hotels

29
Cousin's Cancer, from the **Dear God** series, 2007–10
Oil on canvas; 30 × 30 in.
Courtesy of Bernice Steinbaum Gallery, Miami

30
Diamonds, from the **Dear God** series, 2007–10
Oil on canvas; 30 × 30 in.
Collection of Bernice Steinbaum, Miami

31
Driver's License, from the **Dear God** series, 2007–10
Oil on canvas; 30 × 30 in.
Courtesy of Bernice Steinbaum Gallery, Miami

32
Barack Obama, from the **Dear God** series, 2007–10
Oil on canvas; 30 × 30 in.
Collection of Peter Lange, Durham, NC

33
Vegas Vacation, from the **Dear God** series, 2007–10
Oil on canvas; 30 × 30 in.
Courtesy of Bernice Steinbaum Gallery, Miami

34
Kennedy Died, from the **Dear God** series, 2007–10
Oil on canvas; 30 × 30 in.
Courtesy of Bernice Steinbaum Gallery, Miami

35
Prison–Artist, from the **Dear God** series, 2007–10
Oil on canvas; 30 × 30 in.
Courtesy of Bernice Steinbaum Gallery, Miami

36
Depression and Shoes, from the **Dear God** series, 2007–10
Oil on canvas; 30 × 30 in.
Courtesy of Bernice Steinbaum Gallery, Miami

37
Finding Peace #1, 2009
Oil on canvas; 30 × 40 in.
Courtesy of Craven Allen Gallery, Durham, NC

38
Depression, 2010
Oil on canvas; five panels, each 30 × 40 in.
Courtesy of Craven Allen Gallery, Durham, NC

39
Renee Drinking Starbucks, 2011
Oil on canvas; 30 × 108 in. overall
Courtesy of Craven Allen Gallery, Durham, NC

40
Annah Pregnant, 2013
Oil on canvas; 48 × 48 in.
Courtesy of Craven Allen Gallery, Durham, NC

41
Bill T. Jones, 2013
Oil on canvas; 48 × 48 in.
Collection of the National Portrait Gallery, Smithsonian
Institution, Washington, DC

42
Dorothy, 2013
Oil on canvas; 40 × 30 in.
Courtesy of Craven Allen Gallery, Durham, NC

43
Double Amputee, 2013
Oil on canvas; 48 × 36 in.
Courtesy of Craven Allen Gallery, Durham, NC

44
Pre-Breast Surgery #2, 2013
Oil on canvas; 48 × 36 in.
Courtesy of Craven Allen Gallery, Durham, NC

45
Kim Coming Out of Anesthesia, 2015
Oil on canvas; 40 × 30 in.
Collection of Stan and Kim Boganey, Phoenix

46
Daddy's Birthday, 2015
Oil on canvas; 60 × 60 in.
Courtesy of Bernice Steinbaum Gallery, Miami

47
Philip Pearlstein, 2015
Oil on canvas; 30 × 30 in.
Courtesy of Craven Allen Gallery, Durham, NC

48
Cardrew 2, 2016
Oil on canvas; 30 × 30 in.
Courtesy of Craven Allen Gallery, Durham, NC

49
Loving Grace, 2016
Oil on canvas; 30 × 30 in.
Courtesy of Betty Cuningham Gallery, New York

50
Clown Portrait, 2018
Oil on canvas; 45 × 34 in.
Collection of Billie Tsien and Tod Williams, New York

51
Brown Girl Memory, 2018
(collaboration with Gaetona Casseli)
Oil and mixed media on canvas; 77 × 38 in.
Collection of Laura Lee Brown and Steve Wilson,
21c Museum Hotels

52
Black Girl Beauty, 2018
Oil on canvas; 48 × 48 in.
Collection of Matthew Polk and Amy Gould,
Gibson Island, MD

53
Sharon Pushing Up Daisies #1, 2018
Oil on canvas; 29 × 45 in.
Courtesy of Craven Allen Gallery, Durham, NC

54
Larry, 2018
Oil on canvas; 72 × 60 in.
Collection of Lawrence Wheeler, Chapel Hill, NC

55
Eiko Collaborative Painting 1, 2019
Oil on canvas; 39 × 58 in.
Courtesy of Craven Allen Gallery, Durham, NC

56
Eiko Collaborative Painting 2, 2019
Oil on canvas; 60 × 48 in.
Courtesy of Craven Allen Gallery, Durham, NC

57
Eiko Collaborative Painting 3, 2019
Oil on canvas; 64 ½ × 38 ½ in.
Courtesy of Craven Allen Gallery, Durham, NC

58
Enough, 2020
Oil on canvas; 30 × 24 in.
Courtesy of Craven Allen Gallery, Durham, NC

59
Defiant, 2020
Oil on canvas; 40 × 40 in.
Collection of Laura Lee Brown and Steve Wilson,
21c Museum Hotels

60
Praying Hands, 2020
Oil on canvas; 40 × 30 in.
Courtesy of Betty Cuningham Gallery, New York

ELIZABETH LENTZ

61
Self-Portrait, 1982
Oil on paper; 21 × 18 in.
Collection of Paul and Christy Winterhoff,
Hillsborough, NC

62
Untitled (Still Life), 1984
Oil on paper; 22 × 28 in.
Collection of Paul and Christy Winterhoff,
Hillsborough, NC

RICHARD MAYHEW

63
Untitled Landscape, c. 2006
Oil on canvas; 31 × 37 in.
Collection of Beverly McIver, Chapel Hill, NC

64
Untitled Portrait of a Black Woman, c. 1990
Pastel on paper; 18 × 15 in.
Collection of Beverly McIver, Chapel Hill, NC

FAITH RINGGOLD

65
Tar Beach #2, 1990–92
Silkscreen on silk; 66 × 65 in.
Courtesy of ACA Galleries, New York

ERNIE BUTTON

66
Ethel at the Sink, 2002
Gelatin silver print; 15 × 18 in.

67
Lillie and Ellen, 2002
Gelatin silver print; 15 × 18 in.

68
Support, 2002
Gelatin silver print; 15 × 18 in.

69
Mother Horton, 2002
Gelatin silver print; 15 × 18 in.

MELISSA M BUTTON

70
extensions beyond this point, 2016
Mixed-media collage; 15 × 15 in.

71
portals of perception, 2016
Mixed-media collage; 15 × 15 in.

CLAUDIO DICOCHEA

72
De Teniente Comandante y el caso de la ceacia liberadora, la Barbaridad, 2017
Acrylic, graphite, charcoal, and transfer on wood;
48 × 36 in.
Courtesy of Lisa Sette Gallery, Phoenix

MICHAEL DIXON

73
Make America Great Again, 2017
Oil on canvas; 48 × 48 in.

CARRIE HOTT

74
Motion Zone 1, 2019
Digital print; 14 × 17 in.

75
Motion Zone 2, 2019
Digital print; 14 × 17 in.

MARY PORTERFIELD

76
In Silence, 2017
Oil on layered glassine; 30 × 60 in.
Collection of Rockford Art Museum, IL

CHRIS SANTA MARIA

77
No. 5, 2014
Paper collage and acrylic on MDF; 58 × 60 in.

DAMIAN STAMER

78
New Sharon Church Rd 49, 2018
Oil on panel; 72 × 48 in.
Collection of Lee and Libby Buck, Chapel Hill, NC

LAMAR WHIDBEE

79
Prodigal Son, 2017
Mixed media (door frame, oil paint, cubic zirconia, exit
sign); 83 × 36 in.

SELECTED BIOGRAPHY AND BIBLIOGRAPHY

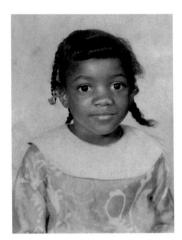

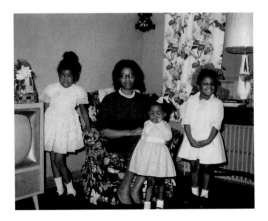

(Top) Beverly McIver's second-grade class portrait, 1972. (Bottom) The McIver family: Renee, mother Ethel, Beverly, and Roni, Easter Sunday 1966.

EDUCATION

2007 Honorary doctorate, North Carolina Central University, Durham

1992 MFA, painting and drawing, Pennsylvania State University, University Park

1987 BA, painting and drawing, North Carolina Central University, Durham

PROFESSIONAL EXPERIENCE

2014–present Professor of the Practice of Visual Arts, Duke University, Durham, NC

2007–14 SunTrust Endowed Chair Professor of Art, North Carolina Central University, Durham

2004–present Artist leader, Professional Development Program, Creative Capital, New York

1996–2007 Professor, Arizona State University, Tempe

SELECTED AWARDS

2017 Joseph H. Hazen Rome Prize, American Academy in Rome

Lifetime Achievement Award, Anyone Can Fly Foundation, Englewood, NJ

Purchase Award, Hassam, Spiecher, Betts and Symons Purchase Fund, American Academy of Arts and Letters, New York

2012 Marie Walsh Sharpe Foundation Studio Program, one-year free studio space, Brooklyn

2010 Distinguished Alumni Fellow, Pennsylvania State University, State College

2004 Artist of the Year Award, Scottsdale Cultural Council

2003 Distinguished Alumni Award, Pennsylvania State University, State College

Marie Walsh Sharpe Foundation, studio space for one year, New York

Louis Comfort Tiffany Award, New York

2002 Project grant, Creative Capital, New York

Radcliffe Fellow, Radcliffe Institute for Advanced Study at Harvard University, Cambridge, MA

2001 John Simon Guggenheim Fellowship, New York

2000 Anonymous Was a Woman Grant, New York

SELECTED COLLECTIONS

Ashville Art Museum, NC

Baltimore Museum of Art

Cameron Art Museum, Wilmington, NC

Crocker Art Museum, Sacramento, CA

David C. Driskell Center for the Study of the Visual Arts and Culture of African Americans and the African Diaspora, University of Maryland, College Park

GlaxoSmithKline, Morrisville, NC

High Museum of Art, Atlanta

Mesa Contemporary Arts Museum, AZ

Mint Museum, Charlotte, NC

Nasher Art Museum, Duke University, Durham, NC

National Portrait Gallery, Smithsonian Institution, Washington, DC

Nelson Fine Arts Center, Arizona State University, Tempe

North Carolina Museum of Art, Raleigh

Pennsylvania Academy of the Fine Arts, Philadelphia

Scottsdale Museum of Contemporary Art

21c Museum Hotels, United States

Weatherspoon Art Museum, Greensboro, NC

RESIDENCIES

2017–18 American Academy in Rome

2016 Yaddo, Saratoga Springs, NY

2014 Knight Fellow, McColl Center, Charlotte, NC

2008 Pilchuck Glass School, Seattle

2007 Yaddo, Saratoga Springs, NY

2000 Djerassi Resident Artists Program, Woodside, CA

Yaddo, Saratoga Springs, NY

1995 Headlands Center for the Arts, Sausalito, CA

1994 Atlantic Center for the Arts, Workshop conducted by Alex Katz, New Smyrna Beach, FL

1992 Atlantic Center for the Arts, The African American Experience, New Smyrna Beach, FL (assistant to Faith Ringgold; scholarship)

SELECTED SOLO EXHIBITIONS

2021 *The Light Within*, Craven Allen Gallery, Durham, NC, November 14–April 3

2020 *Beverly McIver: New Work*, Betty Cuningham Gallery, New York, virtual exhibit, September 4–October 2

(Top) Beverly McIver's high school graduation portrait, 1981. (Middle) Beverly McIver (in red) with her sister Renee, mother Ethel, and sister Roni, c. 1980s. (Bottom) Beverly McIver as a clown, c. 1988.

2019 *You Are There, All You Need Is Love*, Bernice Steinbaum Gallery, Miami, November 16, 2019–January 4, 2020
 Souls of Mine, C. Grimaldis Gallery, Baltimore, February 28–April 6

2017 *12 x 12: Beverly McIver*, Southeastern Center for Contemporary Art, Winston-Salem, NC January 17–February 12

2016 *Objects of Affection*, Betty Cuningham Gallery, New York, September 7–October 15
 The Ties that Bind, Craven Allen Gallery, Durham, NC, February 20–April 9

2013 *New York Stories by Beverly McIver*, Craven Allen Gallery, Durham, NC, October 12–December 28
 Beverly McIver: Paintings, Betty Cuningham Gallery, New York, June 27–August 9

2012 *Beverly McIver: Small Works*, Craven Allen Gallery, Durham, NC, February 25–May 5
 Reflections: Portraits by Beverly McIver, North Carolina Museum of Art, Raleigh, NC, January 4–June 24; Mint Museum, Charlotte, NC, October 20, 2012–January 6, 2013

2011 *Beverly McIver: Paintings*, Betty Cuningham Gallery, New York, May 19–July 1

2010 *Face to Face*, Boulder Museum of Contemporary Art, CO, February 5–Mary 23

2009 *Coming Home: Beverly McIver*, Walter E. Terhune Gallery, Owens Community College, Toledo, OH February 23–March 26

2007 *Raising Renee and Other Themes*, North Carolina Central University Art Museum, Durham, NC, February 18–April 20

2006 *Invisible Me*, Kent Gallery, New York, March 3–April 15
 Raising Renee: Paintings by Beverly McIver, Addison Gallery of American Art, Phillips Academy, Andover, MA, January 3–February 1

2005 *The Many Faces of Beverly McIver*, 40 Acres Art Gallery, Sacramento, September 1–November 14

2004 *Beverly McIver: Paintings*, Weatherspoon Art Museum, Greensboro, NC, October 10–December 19

2003 New Paintings, Kent Gallery, New York, October 2–25
 Mammy How I Love You, C. Grimaldis Gallery, Baltimore, March 1–29

2000 *Life is Good*, Joseph Gross Gallery, Tucson, October 6–November 9

1998 *Beverly McIver: All of Me*, Scottsdale Museum of Contemporary Art, December 5, 1998–March 14, 1999

1996 *When I Was White*, Theatre Art Galleries, High Point, NC, November 24–December 19
 Self-Portraits as a Clown in Black & White, Tyndall Galleries, Durham, NC, September 10–October 5

SELECTED GROUP EXHIBITIONS

2021 *Silent Streets: Art In the Time of Pandemic*, Mint Museum, Charlotte, NC, April 17–November 21
 Parallels and Peripheries, New York Academy of Art, February 10–March 7
 We're Almost Free, Bernice Steinbaum Gallery, Miami, February 6–28

2020 *Alien Nations*, Coral Gables Museum, FL, December 1, 2020–March 14, 2021
 She Persists, Cameron Art Museum, Wilmington, NC, September 22, 2020–March 31, 2021
 La Familiar, David Klein Gallery, Detroit, September 12–October 24

2018 *12 x 12 Collective*, Southeastern Center for Contemporary Art, Winston-Salem, NC, February 23–April 22
 Cinque Mostre 2018: The Tesseract, American Academy in Rome, February 14–March 25
 Black Value, Fondazione Biagiotti Progetto Arte, Florence, February 8–March 17

2017 *Summer '17*, C. Grimaldis Gallery, Baltimore, June 22–August 26
 Invitational Exhibition of Visual Arts, American Academy of Arts and Letters, New York, March 9–April 9; Purchase Award
 Shifting: African American Women and the Power of Their Gaze, David C. Driskell Center for the Study of the Visual Arts and Culture of African Americans and the African Diaspora, University of Maryland, College Park, March 2–May 26
 A Human Condition, Kent Fine Art, New York, January 17–May 1

2016 *Remix: Themes and Variations in African American Art*, Columbia Museum of Art, SC, April 14–May 3
 Clothesline Musings: Art Inspired by the Clothesline, Cary Arts Center, NC, March 18–April 21
 Dress Up, Speak Up: Costume and Confrontation, 21c Museum Hotel, Durham, NC, February 29–September 30

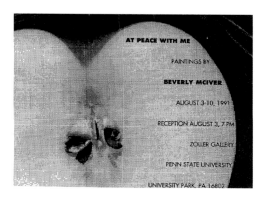

(Top) Invitation to Beverly McIver's first master's thesis exhibition, Pennsylvania State University, 1991. (Middle) Faith Ringgold and Beverly McIver, c. 2017. (Bottom) Richard Mayhew and Beverly McIver, c. 2004.

Introspective, BravinLee programs, New York, February 4–March 19

2013 *Juried Annual Portrait Competition*, National Portrait Gallery, Smithsonian Institution, Washington, DC, June 20–September 15

2012 *The Female Gaze: Artists Making Their World*, Pennsylvania Academy of the Fine Arts, Philadelphia, November 12, 2012–April 7, 2013

2011 *A Selection of Women Artists from the Nasher Museums Collection*, Nasher Museum of Art, Durham, NC, July 23–December 4

2008 *Facing South*, GreenHill Center for North Carolina Art, Greensboro, May

2007 *The "F" Word*, Cynthia Broan Gallery, New York, February 15–March 17

2004 *The Nature of Craft and the Penland Experience*, Mint Museum, Charlotte, NC, July 3, 2004–January 30, 2005

2003 *Hair Stories* (commissioned work), Scottsdale Museum of Contemporary Art, October 3, 2003–January 4, 2004; New Orleans Contemporary Arts Center, February 1–April 10, 2004; Chicago Cultural Center, May 4–July 3, 2004; Crocker Art Museum, Sacramento, July 9–September 11, 2005

American Dream: A Survey, Ronald Feldman Gallery, New York, February 21–April 4

2002 *Free Lemonade*, Robert Miller Gallery, New York, June 21–August 31

SELECTED BIBLIOGRAPHY

2020

Clune, Kathy. "Beverly McIver is Painting Politics." *Duke Arts*, September 8. https://arts.duke.edu/news/beverly-mciver-is-painting-politics/.

Letts, K. A. "Familiar @ David Klein Gallery." *Detroit Art Review*, October 1. https://detroitartreview.com/2020/10/familiar-david-klein-gallery/.

Moriarty, Jim. "The Light Within: In Darkness, Beverly McIver Sees and Paints by the Light and Voice of Truth—and Amazing Grace." *O. Henry* (Greensboro, NC), October, 52–59.

2019

McNairy, Lizzie Cheatham. "Artist Profile: Beverly McIver." *Matrons and Mattresses*, July 5. https://www.matronsandmistresses.com/articles/2019/07/05/beverly-mciver.

2017

Felder, Lynn. "Acclaimed Artist Opening Exhibition at SECCA." *Winston-Salem Journal*, January 15.

Sronce, Joel. "Artist Beverly McIver Discovers a Common Peace." *Triad City Beat*, February 1. https://triad-city-beat.com/25258/.

Yang, Wendy. "The 14 Artworks Every Charlottean Needs to See." *Charlotte (NC) Observer*, January 25.

2016

Beverly McIver: Objects of Affection. New York: Betty Cuningham Gallery.

Hocker, Cliff. "Feel the Paint and the Emotion." *International Review of African American Art Plus*, May 30.

Kelly, Susan Stafford. "Studio Tour: Beverly McIver, Durham." *Our State* (Greensboro, NC), August, 64.

Vitiello, Chris. "In *Dress Up, Speak Up* at 21c, Artists Unravel Clothing and Ornament into Identity Politics." *INDY Week* (Durham, NC), September 28. https://indyweek.com/culture/art/dress-up-speak-21c-artists-unravel-clothing-ornament-identity-politics/.

2015

Fernando, Dillon. "Prof. Bev McIver on Painting, Family and Fragility." *Duke Chronicle* (Durham, NC), June 15.

2014

Jackson, Camille. "A Life that Is 'Good and Scary and Joyous.'" *Duke Today* (Duke University, Durham, NC), September 16.

2013

Frank, Priscilla. "Painter Beverly McIver Talks Clowns, Cindy Sherman and Breast Reduction Surgery." *Huffington Post*, July 31. Updated December 6, 2017. https://www.huffpost.com/entry/beverly-mciver_n_3677587.

Vitiello, Chris. "Being Beverly McIver." *INDY Week* (Durham, NC), October 29. https://indyweek.com/culture/archives/beverly-mciver/.

2012

Green, Penelope. "At Home with Beverly McIver: Painting on a New Canvas." *New York Times*, February 8.

Reflections: Portraits by Beverly McIver. Raleigh, NC: North Carolina Museum of Art. With essays by Kim Curry-Evans, Jennifer Dasal and Beverly McIver.

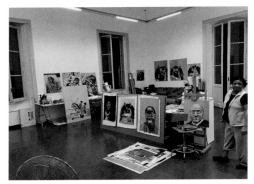

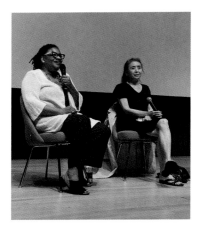

(Top) Beverly McIver's father, Cardrew Davis, and cousin Sharon Brooks, c. 2015. (Middle) Beverly McIver in her studio at the American Academy in Rome, 2018. (Bottom) Beverly McIver and Eiko Otake, 2019.

2011
Rubinstein, Raphael. "2011's Top Ten in Painting." *Art in America*, December 27. https://www.artnews.com/art-in-america/features/top-ten-in-painting-2011-58637/.
Vitiello, Chris. "Durham Artist Beverly McIver Lifts Curtain on Her Life in Raising Renee." *INDY Week* (Durham, NC), April 13. https://indyweek.com/guides/archives/durham-artist-beverly-mciver-lifts-curtain-life-raising-renee/.

2007
Beverly McIver: Raising Renee and Other Themes. Durham, NC: North Carolina Central University Art Museum. With an essay by Kenneth G. Rogers.

2006
Beverly McIver: Invisible Me. New York: Kent Gallery. With an essay by Irving Sandler.

2005
Davis, Kathryn M. "Beverly McIver: Raising Renee." *The Magazine* (Santa Fe), April.
Koster, Michael. "Her Clowning Glory." *Pastiempo* (Santa Fe), March 4–10.
St. Lewis, Louis. "Lifting the Soul." Artist-at-Large. *Metro Magazine* (Raleigh, NC), February, 61.
Willie, Sarah Susannah. "Beverly McIver's Canvas." *Contexts*, November 1, 74–77.

2004
Beverly McIver: Paintings. Greensboro: Weatherspoon Art Museum. With an essay by Raphael Rubinstein.
The Many Faces of Beverly McIver. Sacramento: 40 Acres Art Gallery. With an essay by Leslie King-Hammond.
White, Tim. "Class Clown," *Sacramento News and Review*, October 7.

2003
Mammy How I Love You. Culowhee, NC: A. K. Hinds University Center, Western Carolina University. With essays by Kim Curry-Evans and Dennis Nurkse.
McNatt, Glenn. "Facing Up to Disturbing Racial Stereotypes, Beverly McIver Uses Blackface in Her Art to Transform the 'Mammy' Myth," *Baltimore Sun*, March 9.

2002
Burnett, Roberta. "Gallery Does Right Thing in Hanging 'Brave Work.'" *Arizona Republic* (Phoenix), June 21.
Rubinstein, Raphael. "Report from Arizona: Not a Mirage," *Art in America* (December): 41–47.

2001
Villani, John Carlos. "ASU Art Professor Honored with Guggenheim Fellowship." *Arizona Republic* (Phoenix), May 5.

1999
Yost, Barbara. "All of Her." *Arizona Republic* (Phoenix) January 16.

1998
Rose, Joshua. "Clown's Art? Beverly McIver's Work Is No Three-Ring Circus." *The Tribune* (Phoenix), December 3, 30.

1996
Ariail, Kate Dobbs. "Radical Grace." *Independent Weekly* (Raleigh, NC), October 12–18, 21–22.
Gant-Hill, Cathy. "An Artist's Journey from White to Black." *News & Record* (Greensboro, NC), November 16.
Lacy, Bridgette A. "Black Tears in a Clown Face." *News & Observer* (Raleigh, NC).

Videography
2018
Beverly McIver e il colore nero. Rome: Rai scuola, 2018. https://www.youtube.com/watch?v=vtaF_Z1XniM.

2011
Jordan, Jeanne, and Steven Ascher, dirs. *Raising Renee: A Promise is a Promise*. Newton, MA: West City Films. Aired 2012–15 on HBO. https://www.amazon.com/Raising-Renee-Beverly-McIver/dp/B06XWP3GLQ. Received Emmy nomination for Outstanding Arts and Culture Programming, 2013.

INDEX